THE WEST PLAINS
DANCE HALL
EXPLOSION

THE WEST PLAINS
DANCE HALL
EXPLOSION

LIN WATERHOUSE

Charleston London

THE
History
PRESS

Published by The History Press
Charleston, SC 29403
www.historypress.net

Copyright © 2010 by Lin Waterhouse
All rights reserved

Cover images courtesy of Toney Aid.

First published 2010

Manufactured in the United States

ISBN 978.1.60949.116.1

Library of Congress CIP data applied for.

Dedicated to the victims of the Bond Hall explosion,
April 13, 1928,
West Plains, Missouri

CONTENTS

ACKNOWLEDGEMENTS

Special thanks to Walt Harrington, Carol Moore McInnis and Frank Martin III, who donated their time and professional expertise to editing this volume.

My sincere appreciation to the people who assisted me in my research: Toney Aid, Dorothy Allen, Jim Allen, Tom Aley, John Barton, Tim Bean, Rosanne Brueggemann, Carla Mullins Burns, Edna Carver, Russ Cochran, Jim Decker, Terry Danahy, Dorothy Davidson, Jim Decker, Steve Dennis, Glen and Ina Downen, Charles Drago, Virginia Wiser Graham, John Harlin, Susan Holladay, Leona Jenkins, Dr. Hank Macler, Frank Martin III, Mary Metcalf, Steve McBride, Jim McFarland, Carol Moore McInnis, Dr. Edgar D. McKinney, Dr. James Miller, Cindy Moore, Robert Moore, Barbara Wiser Morgan, Sharon Orlikowski, Dorotha Reavis, Marideth Sisco, Linda Thompson, Garet Waterhouse, the staff of the West Plains Public Library and Paul Wiser.

Thanks also to Kathaleen McCrite Deiser for her support and advice; my daughter, Jenna Richter, and granddaughters, Rachel and Allison Richter, for their blind faith in my storytelling ability; and to my husband, Dave Waterhouse, for his uncomplaining acceptance of my obsession.

INTRODUCTION

"Virtually an earthly hell"—that was the description from a witness to the firestorm that swept the 100 Block of East Main Street in the south-central Missouri town of West Plains in April 1928. The conflagration followed a massive explosion at 11:05 p.m. on a rainy Friday the thirteenth.

That evening, sixty people had gathered in Bond Hall to socialize and dance to the popular tunes of the time. Most were young, the children of prominent families and the next generation of community leaders. Hardly a home in the small town escaped the loss of a son or daughter, niece or nephew, acquaintance or lifelong friend. The community's shock at the physical devastation of the downtown business district paled in comparison to the emotional tremor generated by the terrible loss of life. "Why?" wailed the grieving citizens. Eighty years later, that question is still unanswered.

In 2000, my husband and I settled on the farm that had been his boyhood home in the rural Missouri Ozarks, and I launched a career as a freelance writer focusing on the region's rich history. After hearing about the mysterious 1928 dance hall explosion that claimed thirty-nine lives in the town of West Plains, I approached Fred Pfister, the editor of the *Ozarks Mountaineer* magazine, with a proposal to write an article about the disaster.

After the article appeared in the March/April 2007 issue of the *Mountaineer*, I tried to forget the explosion to concentrate on new projects. The location of the blast is only a few yards from today's West Plains courthouse square, and every time I drove east on Main Street past the site, I thought of the people who died there. While researching other historical subjects, I chanced

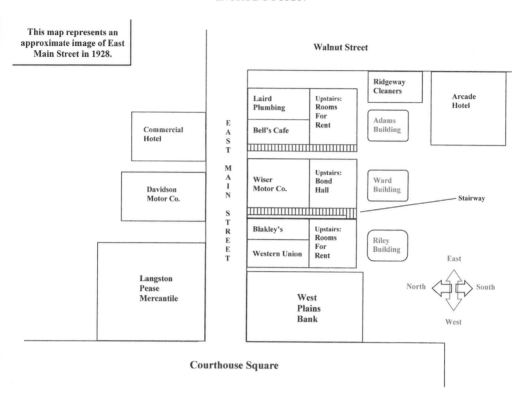

Approximate map of East Main Street in 1928. *Courtesy of the author.*

on photos, documents and personal accounts of the explosion. On grainy microfilm reels of old newspapers, I read chatty society columns about baby showers the victims had hosted, their anniversaries and birthday parties, the novels they read in their book clubs and the motor and train trips they took to visit family and friends. I also read their obituaries. I felt as if I had known them personally.

The conflicting accounts of the circumstances of the explosion piqued my curiosity, and the failure of authorities to determine a cause offended my sense of justice. The story presented all of the elements of a compelling mystery: sudden, horrendous death; contradictory statements of witnesses; heroism of victims and bystanders; community-wide grief; worldwide sympathy; an inexplicably incomplete investigation; and whispered gossip and rumors. Viewed against the wider themes of the 1920s (e.g., secular versus Christian values, the evolving roles of women in America and the government's futile efforts to legislate morality), the story of the explosion is

as pertinent today as it was in 1928. Intrigued by the subject, I questioned my husband's family members about the explosion until one of them suggested that I "just leave it alone."

Then one night I had a dream: The air is heavy with the earthy scent of newly turned soil. A group of people, barely visible in deep shadows, are assembled before me. I peer into the gloom, and I see men in broad-brimmed hats and tweed suits and women wearing party dresses. One woman stands away from the others. Her dark hair is bobbed, and her red dress is dropped at the waist and trimmed with beads. Ambient light, faintly blue like a moonlit night in the country, glints off her body. No one smiles or speaks, but I am not afraid. I just know that they want something from me.

When the dream reappeared regularly, logical thinking told me that it was only a manifestation of my curiosity about that evening, but I also wondered if restless souls seek out earthly assistance to tell their stories. I only know that once I made up my mind to write this book, my midnight visitors quit calling.

With the goal of melding the facts, fiction and theories of the event with present-day knowledge and perspectives, I drew on multiple resources. My primary source was the microfilm copies of the *West Plains Daily Quill*, the *West Plains Gazette* and the *West Plains Journal* from the 1920s and 1930s that are housed at the West Plains Public Library. Publisher Russ Cochran permitted my use of information from the *West Plains Gazette* newspaper archives, and Frank Martin III, editor and publisher of the *West Plains Daily Quill*, assisted in my research. Further, interviews with descendants of the victims gave me insight into the impact of the tragedy on the victims' families and the community.

Author, historian and archivist Dorotha Reavis shared with me what I believe is one of only two surviving copies of the transcript of the coroner's jury investigation. In a time before tape recorders and word processors, the stenographer surely struggled to capture the verbatim accounts of fifty-nine witnesses with intimate knowledge of the night's events. The tattered and yellowed pages appear to be multi-duplicated copies of testimonies, and the last line on almost every page has been lost to the replication process. The report contains numerous typographical and grammatical errors, and in at least two cases, testimonies run together in a confusing jumble of statements and opinions. Despite its limitations, the report provides comprehensive data about the explosion and the investigative procedure conducted by the coroner's jury.

A palpable sense of stunned grief survives in the report's pages. The words of Clara Wiser throb with distress as she defends her husband against

the rising tide of accusations. Icie Risner's anguished parents cling to the hope that their daughter has somehow survived, and Arnold Merk stoically explains how he identified the body of his son from the clothing he was wearing that night.

I have attempted to place the account within the context of historical time and place because I believe the unique characteristics of the Ozarks region and the economic, political and social changes in America in the 1920s all contribute to an understanding of the event.

The explosion changed more than the infrastructure of West Plains. The deaths of thirty-nine victims in the community of only 3,350 people forever altered the lives, attitudes and sensibilities of the citizenry. Although redevelopment repaired the damage to West Plains' business and government districts, and though time claimed the survivors and witnesses, the events of April 13, 1928, will never be completely erased from the psyche of this Ozark community.

THE DANCERS

In April 1928, Kitty and her young son were the only McFarlands living in the fine Victorian home on Grace Avenue in West Plains. In 1923, within just a few months' time, Kitty had lost her husband, Ray, and both his parents, John and Bertie McFarland. Kitty and her son, named John Henry McFarland after his paternal grandfather and nicknamed "Jackie," occupied the family home with a staff of servants that included maids Bertha Brazeal and Nancy Wade. Nancy's brother, Eugene "Dummy" Smith, was also a servant in the home. Nancy and Eugene were part of the very small black population of West Plains.

Their mother had been a servant in Bertie McFarland's childhood home, and on her deathbed, she had begged the Green family to care for her deaf-mute child Eugene. The boy had grown up in the family learning to cook and perform housework, and he especially loved Bertie, whom he always remembered as a little girl with long golden hair. When Bertie married Jack McFarland, Eugene moved with her into her new home, and after her death, he continued working in the McFarland house caring for Kitty and her son.

Ray and Kitty's marriage reflected the spontaneity of the times. On the night Ray proposed, the couple telephoned their friends and asked them to gather on the square, where the couple revealed that they were getting married—right then—in the Episcopal church just a few blocks away. It had been a joyous, impromptu affair for the young, fun-loving couple.

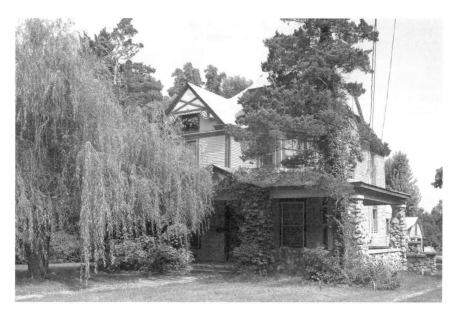

The house that was once the McFarland home on Grace Avenue in West Plains today. *Photo by Lin Waterhouse.*

Ray McFarland was a high-spirited fellow who enjoyed more than an occasional alcoholic beverage. Despite the 1919 law forbidding alcohol consumption, Americans were proclaiming new heights of personal independence in the 1920s, and many citizens viewed Prohibition as little more than a petty inconvenience. Flaunting of the law, especially by socially prominent young people, was generally tolerated, even in a conservative town such as West Plains.

On at least one occasion, John "Jack" McFarland showed his disapproval of his son's behavior. After spotting the outline of a liquor bottle in the back pocket of Ray's trousers, Jack whacked his son on the butt with his cane, smashing the bottle. Jack calmly walked away as the odiferous liquid ran down his son's leg, staining his trousers and filling his shoe.

With wavy, stylishly cropped dark hair and serious eyes, Kitty wasn't the typical widow of the 1920s—penniless and despondent without Social Security or institutionalized welfare to see her through to another marriage. When she married into the McFarland family, they had been undertakers for almost thirty years. After her wedding to Ray in 1914, Kitty passed the State of Missouri's test to become a licensed embalmer, becoming the first female mortician in the state. Following the death of her husband and his parents, she operated the business with competence, professionalism and style.

Kitty McFarland owned and operated the finest mortuary in West Plains. *Courtesy of the* West Plains Daily Quill.

On April 12, 1928, the day before the dance at Bond Hall, Kitty McFarland announced that she would remodel a handsome, two-story brick residence on West Main Street into an elegant, modern mortuary to be called the McFarland Memorial Funeral Home. She planned to give up the house on Grace Avenue to live in a large apartment on the second floor of the new mortuary. Although some thought the living arrangement macabre, Kitty apparently held no superstitions about death. Her advertisements for the funeral business were almost poetic.

> *As the Dial Marks the passing of time*
> *Our loved ones go on to the great beyond.*
> *Our service to you in time of bereavement is*
> *one of quick sympathy and*
> *thoughtful consideration.*
> *McFarland's*
> *Funeral Directors,*
> *Embalmers and Florists*
> *Ambulance Service*

Bob Mullins—decorated soldier, businessman and socialite. *Courtesy of the* West Plains Daily Quill.

According to rumors, Kitty also planned to give her twelve-year-old son a stepfather, a genuine hero a boy could admire. Friends whispered that she and Bob Mullins, the son of West Plains pioneer H.R. Mullins, were planning to announce their engagement.

Mullins was a major in the 140th Missouri Infantry based in his hometown. In 1916, he fought in the Mexican Expedition in pursuit of the bandit Pancho Villa with the city's Company D army unit, and he served overseas during World War I, receiving multiple citations for bravery.

By all accounts, Mullins displayed an elegant worldliness, perhaps a byproduct of his military service. The World War I memorial in West Plains lists the names of thirty-nine local men who lost their lives in the conflict that President Woodrow Wilson called "the war to end all wars." Farm boys who had never strayed more than a few miles from their birthplaces saw battle around the world, staring in wide-eyed amazement at the ancient towers of London and the scandalous women of Paris. After the armistice, they mustered out to return to their homes with a new sophistication.

Although well known for his war exploits, Bob Mullins was in the produce business like his father before him. Mullins's late wife, Eva Jane Reed Mullins, was the daughter of another wealthy fruits and vegetables dealer, so his knowledge of the business ran deep. By the spring of 1928, Mullins had established his own produce business and acquired the West Plains Ice Company, converting it into a modern cold storage and poultry plant. In West Plains, he was recognized as a soldier, businessman and socialite.

Bob Mullins's twenty-two-year-old brother Carl was a skilled musician, a trap drummer who performed in local plays and musical events in south-central Missouri. Recently married to nineteen-year-old Naomi Reeves, Carl

Mullins was part of the combo providing the music at Bond Hall on April 13. Regulars at the weekly dances, the young couple had just learned that Naomi was pregnant, and Carl had given her a locket to celebrate their love.

For this first dance after the Lenten season, Robert Martin and his wife, Soula Maxey Martin, organizers of the weekly dances at Bond Hall, had booked an out-of-town orchestra, but the band had canceled at the last minute, and the Martins called on local musicians Carl Mullins and Dail Allen, a trumpet player, to perform. Because the Martins had given the regular piano player, Henrietta Martin, the night off, they asked their daughter, Soula Gaines Martin, to fill in on the keys. Although twenty-one-year-old Soula had intended to spend the evening with out-of-town friends, she agreed to play the piano as the third member of the trio.

Named after her mother, Soula was a willowy beauty with her red hair cut into a stylish bob. A talented musician and dancer, she won a tryout for the movies in a beauty contest sponsored by the Newman Theater in Kansas City in 1926.

Soula had a memorable smile, and her childhood nickname of "Dimple" stuck with her into adulthood. After graduation from West Plains High School, she entered Miss Wiley's Secretarial School in Memphis, Tennessee, where her older sister, Blanche, was also a student. After the Easter holiday, Blanche returned to Tennessee to spend time with her new beau, J. Fant Rogers, but Dimple had decided to take a break from her studies to work at her father's business, the largest of the Ford dealerships in West Plains.

Soula Gaines Martin played the piano with the evening's trio of musicians. *Courtesy of the* West Plains Daily Quill.

In 1922, Blanche had married Lev Reed, the son of the prosperous owner of the Reed-Harlin Grocer Company in West Plains, but they divorced in 1927. A year later, she was a college student with a new man in her life, and she was the only member of her family absent from the Bond Hall dance on April 13.

In 1928, selling Fords was a lucrative business. In an era of technological innovations, Henry Ford devised an ingenious method to build his Model T cars. Previously, each auto was built part by part, from start to finish, but Ford positioned workers along an assembly line where each man specialized in a single aspect of the vehicles' construction. This manufacturing revolution produced a new automobile every twenty-four seconds and lowered the price for a shiny new Ford from $850 in 1908 to $280 in 1925. Suddenly, people of moderate incomes could own a car, and Ford had sold fifteen million automobiles by 1927.

In December of that year, Bob Martin staged a showy unveiling for Ford's new Model A. Covering his display windows to keep the public in suspense, he decorated his business entirely in blue for the all-night debut party that was front-page news in West Plains.

Alma "Fern" Pumphrey McBride, about 1924. *Courtesy of Steve McBride.*

Before coming to Missouri, Martin had worked as a railroad station agent for the Frisco Line in Mammoth Spring, Arkansas, where he married Soula Maxey in 1901. She was the daughter of Colonel Robert Maxey, a prominent attorney. Descended from southern aristocracy, she was a member of the Daughters of the Confederacy and the Daughters of the American Revolution.

In 1919, the U.S. Congress granted women the right to vote, and Missouri was the eleventh state to ratify the constitutional amendment. After two hundred years of campaigning for women's suffrage, American women like

Mrs. Martin were eager to assume roles of political significance. She was a prominent presence in local and state chapters of the Democratic Party, and she was also president of the West Plains Business and Professional Women's Club. Although she was a recognized community leader, Mrs. Martin was also a woman who loved to dance, and she and her husband sponsored the weekly dances at Bond Hall.

Twenty-year-old Fern McBride and her husband, Garrett, hosted John Bates for dinner in their home that April 13 evening. Garrett was a druggist in the family business, the McBride Drug Company in West Plains, and the couple had been married just two years. Their guest was a charismatic and talented guy. Just twenty years old, he had graduated from Chaffee College in Chaffee, Missouri, in 1926 and continued his education at Hendricks College in Conway, Arkansas. Although John was the son of a Methodist minister, he wasn't stiff or piously somber. He won honors in debate and music at Hendricks, and he played the drums in the military band at Chaffee. He planned to enter the University of Arkansas at Fayetteville to study civil engineering in the fall of 1928. The McBrides and Bates decided to continue their evening at Bond Hall.

Glen Moore usually attended the Bond Hall dances with his girlfriend, Helen McCallon. However, the two had quarreled, and Glen decided to accompany his friend Lev Reed and Lev's date, Juanita Laws, to the dance. A graduate of a business college in Omaha, Nebraska, Juanita worked as a stenographer for Larabee Flour Mills in Kansas City. That weekend, she was visiting her parents, who lived in Cabool, located twenty miles north of West Plains.

Juanita's twenty-two-year-old cousin Ruby Hodkinson

Garrett Randall McBride, about 1924. *Courtesy of Steve McBride.*

was also visiting the Laws family, but Ruby wasn't an eligible career woman like Juanita. Four years earlier, she had married Clifford Hodkinson, and they had a three-year-old son, Clifford Jr. Ruby had just undergone surgery at Vineyard Hospital in Springfield, and she decided that a visit with Juanita's mother, Viva Laws, would be recuperative.

When Lev asked his friend to squire his date's cousin to the dance, Glen agreed. Despite their spat, Glen cared for Helen, and he thought she would not mind if he escorted the happily married Ruby to the dance.

Over six feet tall with curly black hair, twenty-four-year-old Moore was a star player on a local baseball team. After he earned a scholarship to Drury College in Springfield, Moore gave academia a try, but he found college life too quiet. He returned home to Dripping Springs, a small community just north of West Plains.

Athletes like Glen Moore were well admired in their communities. In the 1920s, America was obsessed with sports, and the new invention of radio brought professional competitions into small communities like West Plains. In 1928, the batting prowess of New York Yankee slugger Babe Ruth captivated the nation. Although football and boxing were popular with the public, sports fans could not get enough of baseball. Almost every town in America sponsored local teams, and rivalries were fierce.

Moore and Reed worked together at the Reed-Harlin Wholesale Grocer Company in Cabool, where Reed's father was one of the business's owners. Young Reed was the ex-husband of Blanche Martin and brother to Eva Reed Mullins, Major Bob Mullins's deceased wife. A graduate of the law school at Washington University in St. Louis, Reed also attended Wentworth Military Academy at Lexington, Missouri, and Jackson College in Nashville, Tennessee.

The two young men were great friends, and Lev may have teased Glen about his argument with Helen, assuring him that an evening of music and merriment would heal a battered heart.

Icie Risner was a sixth-grade teacher in Thayer, Missouri, twenty-five miles east of West Plains, and she taught Sunday school at the town's Methodist church. The vivacious twenty-three-year-old redhead lived at home with her parents, John and Josephine Risner, and her younger sister. On Thursday, April 12, Icie and a group of friends rode the Sunnyland Express train from Thayer into West Plains to attend a Methodist Church conference. Icie was familiar with the frivolity at Bond Hall because she had attended a dance there in the fall of 1927, and she wanted to go to the April 13 dance. Both her mother and her sister begged her not to go. The Methodist Church,

like most churches of the time, preached that dancing was sinful, and Mrs. Risner thought it would be especially inappropriate for her daughter to go to the dance following a church function. Despite her family's admonitions, Icie refused to promise that she would not attend.

Icie's family was unaware that she had scheduled a date for Friday night with Mr. Boyd, and they intended to be among the dancers in Bond Hall. The plans were tentative, dependent on the condition of Boyd's brother, Ralph, who was seriously ill with influenza. Boyd told Icie that if his brother continued to improve, he would meet her in West Plains. However, Ralph Boyd took a turn for the worse on Friday, and his concerned brother canceled the date. After the church conference, the disappointed young teacher started home in a car with some other conference attendees, but before they reached Thayer, they met friends who were headed into West Plains for the dance. Alvin Garner, Julian Jeffrey and James Loven convinced Icie to go back to West Plains with them.

Apparently, the young woman didn't hesitate to join the three young men in their car. Chaperones were anachronisms in the 1920s, an era of increased freedom between the sexes. Sigmund Freud's liberal ideas about sexuality altered the rules of courtship, and the popularity of automobiles gave men and women the opportunity to be alone together in what was popularly described as a bedroom on wheels.

In this relaxed social atmosphere, Icie Risner headed back to West Plains to dance the evening away in Bond Hall.

Olis Burdette Holestine was a young man on the

Olis Holestine's family operated a mercantile store in this building, which still stands on the square in Ava, Missouri. The name "Holestine" is still readable on an exterior wall. *Photo by Lin Waterhouse.*

fast track to success in his hometown of Ava, Missouri, sixty miles northwest of West Plains. Nicknamed Chester, Holestine was the son of J.T. Holestine, owner of the prosperous mercantile on the town square, and nephew to the mayor of the town and president of the People's Bank of Ava. An honored graduate of Ava High School, Holestine attended both Washington University in St. Louis and the Southwest Teachers College in Springfield, and at the age of twenty-two, he planned to enter his father's business.

The Burdettes were Ozark pioneers. Olis's grandfather, K.L. Burdett, a physician, was a local legend. Animosity between Union and Confederate supporters continued in border states like Missouri long after the war's end, but Dr. Burdett insisted on treating the sick and injured from both camps equally. His dogged neutrality continued until his death in 1902.

Olis Holestine drove forty miles with his friend Charles Fisher to attend the Bond Hall dance. *Courtesy of the* West Plains Daily Quill.

Young Holestine cut a dashing figure with his stylish wardrobe and flashy new automobile. On April 13, 1928, he set out with his friend, Charles Fisher, to drive the rutted dirt roads from Ava to West Plains to attend the dance at Bond Hall.

Twenty-year-old Charles Fisher was the only son of Mr. and Mrs. Dolph Fisher of Ava. The Fishers operated the Ozark Hotel located on Ava's main street. The large, two-story, wood-frame lodging was a popular stopover for people making the one-hundred-mile journey between Springfield and West Plains. Many of the visitors were traveling salesmen who peddled their inventories of wares from town to town.

Consumerism was born in the 1920s, and the fledgling profession of public

24

advertising convinced ordinary folks that household appliances were not just for the rich. Anyone could afford those luxuries through another innovation of the age of consumerism: installment payments. Door-to-door, newspaper and radio advertising encouraged people to buy now and pay later, promising that the rising fortunes of the country would provide the funds to pay for every indulgence. Americans bought homes in record numbers, filled them with timesaving devices and parked shiny new automobiles outside their doors—all through the miracle of time-payment plans.

Before moving to Ava, Charles Fisher had been a star athlete at his high school in Mountain Grove, Missouri. In 1926, he entered Kirksville Teachers College in Kirksville, Missouri, where he was an outstanding player on both the basketball squad and the football team. In recognition of his athletic accomplishments, the college presented him with two gold watch charms, one for each sport, and Fisher wore them proudly. On the night of the dance, Fisher was home from college. After borrowing a suit from his best friend, Van Dennis, he and Holestine headed off to the dance.

In 1928, Charles Fisher's parents operated the Ozark Hotel in this building on Main Street in Ava, Missouri. *Photo by Lin Waterhouse.*

Forty miles of rough roads connected Ava and West Plains, but for the two high-spirited young men, the long trip to the dance was an adventure with an evening of dancing with pretty girls as the prize.

Throughout south-central Missouri and northern Arkansas, young people were preparing for the dance at Bond Hall. All were anticipating lively music and lighthearted fun.

SOURCES

Floyd Arnhart's description of the fire as "virtually an earthly hell" was reported in the April 19, 1928 issue of the *West Plains Daily Quill*.

The information about the McFarland family was culled from death certificates and newspaper articles. Information about Eugene Smith came from an undated newspaper obituary provided by Jim McFarland, grandson of Kitty McFarland, who also told me about his grandparents' impromptu wedding and about John Henry McFarland's blow to the seat of his son's trousers that smashed the bottle of illegal liquor. The anticipated announcement of the engagement of Kitty McFarland and Bob Mullins was mentioned in the April 19, 1928 issue of the *Quill* newspaper and confirmed by Jim McFarland.

The story about Henrietta Martin's fortuitous night off as the regular piano player was included in an article in the *Quill* newspaper of November 6, 2001.

The information about Babe Ruth and baseball in the 1920s came from the Baseball Page website, www.thebaseballpage.com.

The statistics about Ford sales from 1908 to 1925 appeared in "The Politics of Prosperity: The 1920s," at http://us.history.wisc.edu; http://inventors.about.com/od/fstartinventors/a/HenryFord.htm; and http://www.modelt.ca/history.html.

The *Thayer News* of April 20, 1928, told the story of Icie Risner. The first name of Mr. Boyd, Icie's date, was never identified.

Steve Dennis of Tulsa, Oklahoma, told me the story of the suit his grandfather loaned to Charles Fisher.

Information on Kitty McFarland, Robert Mullins, Carl and Naomi Mullins, Bob and Soula Martin, the Martin family, Lev Reed, Glen Moore and the other dancers was obtained from newspaper articles and obituaries of the time, as well as the author's interviews with descendants Steve McBride, grandson of Garrett McBride; Jim McFarland; Carol McInnis, daughter of Glen Moore; Carla Burns, daughter of Carl Mullins; and local historians Dr. Edgar McKinney, Dorotha Reavis, Russ Cochran and Toney Aid.

WEST PLAINS

THE GEM CITY OF THE OZARKS

Temperatures soared to an unseasonable eighty degrees on April 1, 1928—balmy enough for winter-weary citizens to cast aside their heavy clothing and rummage through their closets for the cottons and silks they had stored away the previous fall. Despite dipping to a chilly forty-five degrees on Good Friday, Easter dawned sufficiently sunny and warm on April 8 for the ladies of the town to audition their new spring wardrobes at church services.

On that spring morning, Mayor Jim Harlin might have surveyed the downtown courthouse square of West Plains with pride. Tall and slender, with a lean, patrician face and intense eyes, he had overseen more than a decade of change since being elected to the office in 1914.

The son of pioneer bankers, Harlin first served two years as mayor of West Plains beginning in 1906. That year, Will H.D. Green had been elected to the office but was disqualified when he admitted that he was not yet twenty-five, the legal age required for the position. Jim Harlin was selected to serve Green's term.

The Harlins were among the Ozarks' earliest entrepreneurs. One of the founders of the Reed-Harlin Wholesale Grocer Company, Jim Harlin was also part of the Ozark County Syndicate that owned controlling interest in several area banks.

In 1914, the year Harlin was officially elected mayor, West Plains' voters installed the commission form of city government to replace the old aldermanic style that was rife with corruption. Harlin campaigned under a platform of "no nonsense, no favoritism." During his tenure, he

launched one ambitious plan after another to make his community what local newspapers referred to as the Gem City, a beautiful jewel in the poverty of the rural Ozarks.

West Plains is situated slightly west of the center of the state of Missouri and less than fifty miles north of the Arkansas state line. Its location places it within the geographic area called the Ozarks. The commonly accepted derivation of the name is the French phrase *aux Arks*, which was used to indicate the area's location as "toward Arkansas."

Eons ago, the Ozarks region was covered by a calm, shallow tropical sea. When the organisms living in that sea died, their calcium-rich shells and skeletons solidified into bedrock composed of limestone, dolomite and gypsum. At some point in ancient prehistory, the shallow waters disappeared when magma deep within the earth fractured the bedrock and forced it upward, forming a low, dome-shaped plateau.

The hills and hollows of the Ozarks were not created by upthrust like the Rockies or the Sierras. They are niche mountains, cut and defined by erosion of the plateau. Through the ages, rainwater and acidic groundwater seeped through the cracks and fissures, dissolving the limestone into a complex underground drainage system of sinkholes, caves and subterranean streams and caverns. Thin, rocky soil, hardwood and piney forests, clean-flowing creeks and shimmering lakes characterize the surface of the land.

The Ozark region is roughly composed of that part of Missouri, Arkansas, Kansas and Oklahoma enclosed by mighty rivers: the Missouri River on the north, the Mississippi River on the east, the Black River on the southeast, the Arkansas River on the south and the Spring River on the southwest.

Henry Rowe Schoolcraft recorded the first accounts of life in the Ozarks after his exploration of the area in 1818. A cultured, educated man of the early nineteenth century, he assessed the mostly Scotch-Irish and German residents of the area to be barely civilized, sheltering their huge families in hand-hewn huts and feeding and clothing them from what they could hunt, garden and gather from the land. Despite his shock at their primitive lifestyle, Schoolcraft admired the settlers' friendliness, independence and make-do attitude.

Life in the unforgiving topography of the Ozarks made people tough and self-reliant. Many early settlers had fled their mother countries because of famine and political unrest. They were familiar with hardship and deprivation, and they harbored no illusions about the fairness of life. Farmers struggled behind mule-drawn plows to plant their fields and then watched the destruction of those crops by water, wind or drought. Wives

died in childbirth, and children expired from fevers, tetanus, snakebites or any of the myriad hazards of the frontier. A sense of fatalism pervaded Ozark life, and only the settlers' rigorous religious faith sustained them. Folks trusted that the path determined by God, however hard, would lead the righteous to his heavenly home.

Music was an escape from the daily hardships. A distinctive blend of stringed instruments, old-time country music spoke from the heart. Happy hours of square dancing and jig dancing were balanced by the mournful keen of songs about lost loves, hunger and death. Ozarkers knew that life was a fickle brew. In the documentary film *The Ozarks: Just That Much Hillbilly in Me*, historian Don Holliday explained, "That's why Ozark fiddles wail."

Before the Frisco Line (the St. Louis and San Francisco Railway Company) extended its track into southwest Missouri in the 1860s, few roads breached the Ozark frontier, and the ones that did exist were little more than dirt paths. Letters, newspapers and information traveled a two-day trip by horse and wagon from Rolla, Missouri, one hundred miles to the north, or else settlers made the rugged trek to the nearest dock to meet the steamboats that traveled the White River as far north as Norfork, Arkansas, more than sixty miles from West Plains.

Through trial and error and dogged determination, Ozark farmers coaxed grasses, grains, vegetables and fruits from the stubborn soil. Southern Missouri forests offered tens of thousands of board feet of timber, and rocky cliffs and ledges were lined with lead, copper and silver, but until the Frisco Line chugged into West Plains in February 1883, residents had no way to market the bounty of their land.

The railroad's arrival turned West Plains into a tiny metropolis. Howell County's population rose from 8,800 before the railroad to 18,600 by 1890 and then to 22,000 by the end of the century. West Plains itself grew from 350 people in 1880 to 3,000 in 1900. The 1930 census identified 3,335 people residing in West Plains.

The year 1920 marked the first year that more people lived in cities than on farms in America. Gasoline-powered machinery vastly improved a farm's yield, but the equipment was too expensive for most Ozark farmers. Families that had tilled small parcels of land with horse-drawn plows for generations could no longer compete with mechanized farms, and they abandoned the land to join a migration into the cities, where jobs were plentiful and wages were good, especially on assembly lines producing autos, washing machines, refrigerators and cook stoves. Workers moved into cities, where they could earn $5 per day, and annual income averaged $1,236.

While West Plains' businesses could not offer those huge salaries, they provided secure employment. By 1928, the town enjoyed a solid industrial base that included Aid's Hardware, a Coca-Cola bottling plant, a milk processing plant, Tompsons' cannery, several new and used auto dealerships and gasoline service stations, Swanson's lumberyard, West Plains Transfer and Storage, the Reed-Harlin Grocery Company and Langston's department store. Dozens of successful businesses supported the economy and provided jobs.

By the 1920s, the United States boasted 387,000 miles of roadway. Route 66, the "Main Street of America," linked hundreds of small rural communities in Illinois, Missouri and Kansas. Farmers could transport their products from fields to the city with relative ease, and families could venture west to see the sights along the miracle highway.

Mayor Jim Harlin viewed decent roads as the remedy to the area's isolation, and in 1921 he formed a construction company to build highways throughout the Ozarks. He advocated paving the courthouse square to demonstrate West Plains' prosperity, but his plan encountered opposition. Automobiles were much less reliable than horses or mules, and some folks believed that if they bided their time, society would return to the bucolic simplicity of animal-powered transportation. Others opposed paving because the smooth surfaces were dangerous for the horses that still predominated. Further, civic improvements cost money and that meant raising taxes. Plenty of people frowned at that.

Because the square was built with considerable incline, and the brakes on Model Ts were notoriously unreliable, cars parked on the northwest side often rolled into the storefronts on the opposite side of the square.

Charles Theodore Aid agreed to pay half of the cost of the paving project since his hardware business dominated the south side of the square. At Aid's urging, other shop owners contributed to the improvements, and by 1917, the entire courthouse square had been paved with hand-laid bricks; a high curb protected storefronts and pedestrians from errant vehicles.

The Gothic, hip-roofed, three-storied Howell County Courthouse was the jewel of the city. Built in 1883 at a cost of $16,600, it measured sixty-five feet squared. County offices occupied the first floor, and a courtroom was located on the second floor. The Mount Zion Mason lodge helped to pay for the structure in exchange for use of its third floor for meetings and events.

The charming downtown area with its impressive courthouse, neat brick buildings of commerce, wide sidewalks and paved streets—along with schools, a water and sewer system and electric-powered homes and businesses—attested to West Plains' success. As early as 1911, the West Plains Telephone Company boasted more than three hundred telephone numbers. Businesses on the square

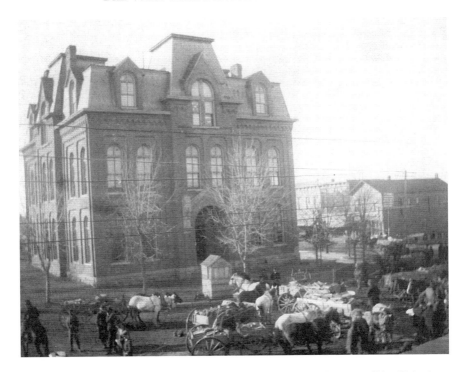

The Howell County Courthouse, built in 1883, was the jewel of downtown West Plains in 1928. *Courtesy of Toney Aid.*

in 1928 included five drugstores, two shoe stores, two hardware stores, four grocery stores, two barbershops, a beauty shop, four banks, three mercantile stores, a milliner, a movie house and an ice cream parlor.

Four newspapers supplied information to curious citizens: the *West Plains Journal*, run by Republican Arch Hollenbeck; the *West Plains Gazette*, operated by Democrat Will Zorn; the apolitical *West Plains Daily Quill*, managed by Cleora, Ella and Fritze Williams, who had inherited the paper from their father, Mills; and the *West Plains Weekly Quill*, operated by the Williams sisters, which came out on Thursdays to summarize the news of the previous week.

Newspaper advertisements appearing in the months before the explosion illustrated the town's booming economy: Peck's Place proclaimed itself the "headquarters for Christmas goods, the bargain store of West Plains"; the Red Apple Drug Store assured patrons that "every care" would be taken when filling prescriptions and suggested: "Bring us your prescription or Family Recipe"; Blakely & Jackson Confectioners guaranteed that "Every Sweet Tooth can be satisfied here"; Bohrer's Drug Store, "The Drug Store of Service," advertised a "Ben Hur Perfume Set" for $2.50; Langston's Store

In 1928, Joseph Wiser's garage occupied the ground floor of the Ward Building shown in this old, undated photo. *Courtesy of Toney Aid.*

for Men offered Stetson hats for $8.00, dress shirts for $2.00 and silk ties for $1.00; and Clyde Williams Shoe Store advertised its "bargain feast in slightly used, high heel straps, pumps and oxfords at an unheard of price."

Bond Hall was a rental hall on the second floor of what was known as the Ward Building because it was owned by Mrs. Leland Ward. The hall was situated directly above Joseph Marion "Babe" Wiser's motor garage. The hall hosted all types of public gatherings (e.g. wedding showers, club meetings and anniversary celebrations), and Bob and Soula Martin rented Bond Hall for the Friday night dances that attracted the richer and more prominent young people of West Plains and nearby communities.

The dances were not the only recreation for West Plains citizens. The fields, forests and rivers surrounding the town offered picnicking, hunting, boating, fishing, camping and hiking. In addition to the enjoyment of nature, numerous baseball teams competed in the warm months.

Traveling circus troupes, fairs, banquets, musicals, equine competitions and vaudeville shows all attracted crowds. The 1893 grand opera house on the west side of the square boasted a theater with a stage, orchestra pit and a second-floor balcony.

By 1923, 400,000 Americans were listening to 556 radio stations, and broadcasts from Chicago and Pittsburgh were popular in the Ozarks.

Shoppers crowded into stores like Aid's Hardware and Bohrer's Drug Store to listen to radios tuned to news, weather, sports and music, and an increasing number of people purchased radios for their homes.

The population of West Plains in the 1920s was mostly white. However, a few black folks, such as Nancy Wade and Eugene Smith, who worked for the McFarland family, lived in the community. The issue of race in West Plains dates back to 1839, when Josiah and Sarah Howell arrived from Tennessee and settled near the spring located just one block east of what would later become West Plain's downtown business district. Along with their children and grandchildren, they brought a number of slaves. The 1860 Howell County Slave Schedule Census counted thirty-six slaves claimed by fifteen citizens.

In the 1920s, the issues of slavery and states' rights were still contentious. Dorotha Reavis, historian and archivist, recounts the story of the winter when Rebels drove Union sympathizers, including old folks, women and children, from their homes and forced them to walk north toward Rolla, where Northern forces were encamped. Many froze to death or died of pneumonia. Roving armies, militias and criminals turned West Plains into a ghost town for much of the Civil War. During the war, the Methodist church congregation in West Plains split along regional lines—North versus South. Although the two factions finally merged into one congregation in the 1920s, residual animosity disappeared only when those who remembered passed on.

The drive for voting rights didn't escape the women of West Plains. Prominent ladies, including newspaper owners Cleora, Ella and Fritze Williams and Alice Cary Risley, president of the Civil War Nurses Association, organized suffrage marches on the square. An old photo in Toney Aid's book *West Plains 1880–1930* shows a group of women assembled on the

The women of West Plains campaigned for women's suffrage on the square about 1919. *Courtesy of Toney Aid.*

courthouse square in cars and on horseback displaying signs demanding "Votes for Women."

Like their city sisters, West Plains women followed fashion trends. Langston's advertised "sheerest chiffon" hosiery for Christmas 1927, and the *West Plains Daily Quill* reported on the latest in ladies' wear. In March 1928, the Business and Professional Women's Club sponsored a fashion show at the Famous Theater in which thirty-five of the city's most prominent young women modeled the newest styles.

West Plains boasted a small city police department directed by Chief of Police J.A. Bridges. When necessary, Sheriff Fred Juren's deputies provided support. The two law enforcement entities handled the small number of crimes occurring in the peaceful community.

In the early decades of the twentieth century, many buildings within the West Plains city limits were old and shabby and subject to fire. After an 1895 fire destroyed much of the southwest corner of the square, West Plains installed its first waterworks in 1901, but the only alarm was the firing of pistols. Later, citizens pounded a mallet on a locomotive wheel positioned near the courthouse to sound the alert. On August 27, 1914, a fire broke out behind the switchboard of the local telephone company located on the second floor of the Aid Hardware building. The entire floor was aflame by the time fire personnel, headed by Fire Chief Joe Martin, arrived with the city's horse-drawn fire truck. Firemen saved the buildings on either side of Aid Hardware, but Aid's business lost more than $50,000 in goods alone. The following year, the fire department's single pumper truck could not prevent the destruction of Langston's department store. About 1918, the city purchased a motorized fire truck, and the city fathers believed that their community was prepared.

That pleasant Easter morning, with the daffodils and redbuds blooming, Mayor Harlin might have smiled with pride. Few towns could boast the physical beauty, social life or technological advancements of West Plains. He had every reason to believe in a bright prosperous future for his beloved hometown and its citizens.

SOURCES

Historic weather information: National Climatic Data Center, National Oceanic and Atmospheric Administration (NOAA).

History of the Harlin family: Cochran, Michael. "The Harlin Brothers: The Story of an Ozark Dynasty." *West Plains Gazette*, no. 8, fall 1980, 22.

Physical and prehistorical description of the Ozarks and its history: *The Ozarks: Just That Much Hillbilly In Me*. Documentary film produced and directed by Mark Biggs for Southwest Missouri State University in conjunction with the Ozarks Studies Institute, 1999, Board of Governors, SMSU; and *Living on Karst in South Central Missouri: A Reference Guide for Ozark Landowners*, originally published by the Cave Conservancy of the Virginias, edited and amended for the Ozarks by the Nature Conservancy, December 2003, the Nature Conservancy, Lower Ozarks Project, with funding from the Monsanto Foundation.

Henry Rowe Schoolcraft's accounts of life in the Ozarks: Schoolcraft, Henry Rowe. *Journal of a Tour into the Interior of Missouri and Arkansaw* (Charleston, SC: Nabu Press, 2010).

History of the Frisco Line in West Plains: Cochran, Michael. "Opening the Door to the Ozarks." *West Plains Gazette*, no. 16, March/April 1982, 14.

The changing U.S. population and the migration from the farms into the cities: Norton, Mary Beth, David M. Katzman, Paul D. Escott, Howard P. Chudacoff, Thomas G. Paterson and William J. Tuttle Jr. *A People and a Nation: A History of the United States*. Volume II, *Since 1865*. (Boston, MA: Houghton Mifflin Company, 1998).

Route 66: National Historic Route 66 Federation. "History of Route 66. Why is this road so important to America?" www.national66.org/66hstry. html; Bradbury, John F., Jr. "The Early Years of Route 66 in Phelps County, Missouri." *Ozarks Watch* 7, no. 2 (Fall 1993/Winter 1994).

Description of the square in the 1920s and an account of the paving of the square: Neathery, Robert. *West Plains As I Knew It* (West Plains, MO: Elder Mountain Press, 2001), 389–95 and 60, respectively; Aid, Toney. *West Plains, 1880–1930* (Charleston, SC: Arcadia Publishing, 2003), 52.

History of the Howell County Courthouse: "Howell County Courthouse," website of the University of Missouri Extension. http://extension.missouri. edu/publications/DisplayPub.aspx?P=UED6045.

The 1911 telephone directory for West Plains and the surrounding area provided a listing of telephones in 1911.

West Plains newspapers and favorite radio stations in the 1920s: Neathery. *West Plains As I Knew It*, 123–24.

Number of Americans listening to radio stations in the 1920s taken from the article "A Godlike Presence: The Impact of Radio on the 1920s and 1930s" by Tom Lewis, Organization of American Historians, www.oah.org, reprinted from *OAH Magazine of History* 6 (Spring 1992), Organization of American Historians.

Women's voting rights: Aid. *West Plains, 1880–1930*, 104.

History of West Plains' fire and law enforcement departments: Aid. *West Plains, 1880–1930*, 75–77.

ADDITIONAL SOURCES

Allen, Frederick Lewis. *Only Yesterday, An Informal History of the 1920s.* New York: Harper & Row, 1931.

"American Cultural History 1920–1929." Kingwood College Library. http://kclibrary.lonestar.edu/decade20.html.

"Radio in the 1920s: Emergence of Radio in the 1920s and Its Cultural Significance." http://xroads.virginia.edu/~ug00/3on1/radioshow/1920radio.htm.

LIFE ON EAST MAIN STREET

T he West Plains square is literally that—a square bisected by streets that enter from each of the four geographic points: Washington Avenue enters from the north, Aid Avenue from the south, West Main Street from the west and East Main Street from the east. The West Plains Bank building with its stone façade and pillared corners has claimed its prime position at the corner of the square and East Main since its construction in 1916.

In 1928, the bank's main entrance faced the square, and a side entrance opened onto East Main. In that first block east of the square, the Riley, Ward and Adams Buildings were aligned on the south side of East Main from west to east, respectively.

In 1928, if a pedestrian left the West Plains Bank and walked east along the south side of East Main Street, he would first pass the Riley Building, which housed Western Union and Blakley's Cream Station on the street level.

Wiser Motor Company, an automobile sales and service business, occupied the lower level of the Ward Building located east of the Riley Building. Bond Hall, the site of the Friday night dances, was situated on the second floor of the Ward Building, directly above the garage.

Bell's Café and Laird Plumbing shared the ground floor of the Adams Building, which was just east of the Ward Building on the corner of East Main and Walnut Streets. Ridgeway Dry Cleaners and the Arcade Hotel were located south of the Adams Building on Walnut Street.

The Riley, Ward and Adams Buildings all offered modest but respectable rooms for rent on their second floors above the street-level businesses.

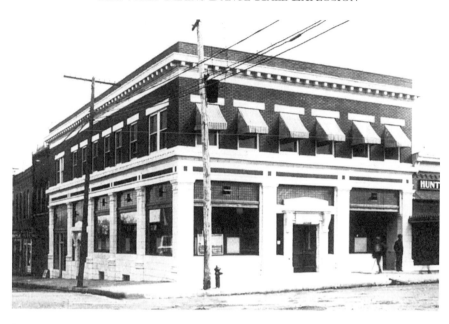

Built in 1916, the West Plains Bank dominated the corner of the square and East Main Street. The explosion destroyed the block of buildings behind the bank. *Courtesy of Toney Aid.*

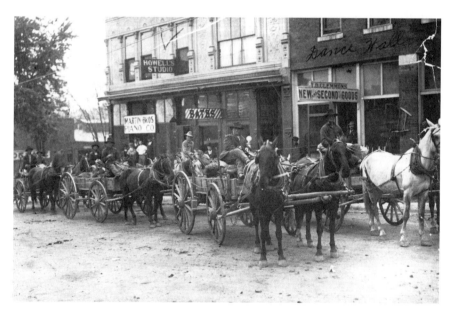

This photo, dated "before 1911," shows the building (at far right) that was the site of the explosion. *Courtesy of Toney Aid.*

These rooms were accessed by exterior wooden stairways leading to the upper floors from the street. In the case of the Ward Building, an interior stairway inside the Wiser Motor Company provided a second entrance to the upper floor.

An old photograph of East Main Street, dated "before 1911," provides a view of the Ward Building. Large windows extended across the front of the ground floor of the brick building. On the second floor, several tall, narrow windows overlooked East Main Street. Judging the age of the building from a grainy photo is problematic. However, the building does not appear to be new. By 1928, almost twenty years after the photo was taken, the old structure's ground floor was cracked and uneven, and the walls would shudder in a stiff wind.

Despite the building's condition, people did not seem to fear gathering there. Centrally located, Bond Hall hosted all types of public gatherings. Newspapers reported numerous social activities in the second-floor hall where the Martins sponsored the regular Friday night dances.

During the dance, people gathered on the sidewalk in front of the building or in the empty field out back, listening to the music that drifted from the hall and socializing with friends. Sometimes a bottle or flask was handed around from person to person, and some people complained about the loud, rowdy behavior exhibited by some of the dance's inebriated patrons.

Although the "dry forces" drove the last saloon from West Plains with an ordinance banning liquor sales in 1907, many people displayed nonchalance toward Prohibition, and others sought to profit from the law. Local newspapers reported numerous arrests for brewing of moonshine liquor, and grocer Carrie Davis was rumored to sell a suspicious number of cases of lemon, vanilla and Jamaica ginger extract that contained a fair amount of alcohol.

J.M. Wiser, whose garage occupied the lower level of the Ward Building, had opened his new and used auto sales company less than a year before the explosion. Testimony following the blast indicated that the newcomer was liked and respected by his employees and by the owners of neighboring businesses.

Ben Jolly was a week shy of his sixty-eighth birthday. A painter who also worked in the automotive department of McFarland's mortuary, he lived alone on the second floor of the Ward Building in a room adjacent to Bond Hall. By 11:00 p.m. on that Friday evening, Jolly had settled into his bed to try to catch a few winks despite the music in the hall adjoining his room.

Frances Wilhelmina "Billy" Drago was the twenty-two-year-old manager of the Western Union office in the Riley Building. After graduating from West

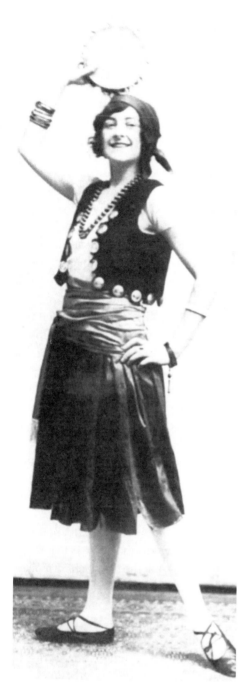

Billy Drago, manager of the Western Union office, loved to perform in local theatrical productions. *Courtesy of Toney Aid.*

Plains High School with honors, she enrolled in a telegraphy course and quickly assumed managerial positions in Emporia and Freedonia, Kansas. In the fall of 1927, Billy got the opportunity to manage the Western Union office in her hometown near her parents, Mr. and Mrs. Charles J. Drago, and her younger siblings, Charles Jr., George and Bobby.

Billy performed in local theatrical and musical productions. A delightful old photo shows the slender, dark-haired girl wearing a gypsy costume and displaying a saucy, dramatic pose. Blessed with an exceptional soprano singing voice, she was also a soloist in the choir of the All Saints Episcopal Church, where she planned to be confirmed in May 1928.

That evening, Billy's sister, Susan Virginia Drago Rogers, was visiting West Plains from Emporia, Kansas. Married to Wallace Rogers, Susan had brought their one-year-old daughter, Patricia Louise, to visit her grandparents. The Bond Hall dance presented an opportunity for Susan to reconnect with old friends.

Warren Blakley's grocery and cream station was the second commercial enterprise in the Riley Building. Blakley and J.M. "Babe" Wiser were well

acquainted because the auto dealer often stopped by the store for drinks or snacks and for conversation about the newest automobile models.

At about 4:00 p.m. on that Friday, Wiser bought some candy from Blakley. The store owner later recalled that the auto dealer seemed distracted.

"He didn't seem anxious to talk," Blakley later testified. "In fact, he didn't answer me." Blakley was surprised by Wiser's reticence; he had always been cordial and genial.

Beverly Owens was a cream buyer for the American Butter Company, and he lived with his wife, Hattie, and their child in rooms behind Blakley's cream station. About 4:30 p.m. on Friday afternoon, Owens noticed Joseph Wiser drive by with a woman in his car—Mrs. Wiser, he assumed. Sometime later in the afternoon, he saw Wiser drive past again, this time alone. Owens thought that Wiser had taken his wife home after a shopping trip and was returning to work. He knew Wiser as a conscientious businessman who often worked late in his garage.

At 7:30 p.m., the Owens family left their home to attend Friday services at the Christian Church. About 9:30 p.m., they returned to discover a foul gasoline smell in their rooms. They later told investigators that they had occasionally smelled fumes from the nearby garage, but nothing so strong and never at night. Five or ten minutes of airing their apartment cleared away the smell, and the little family settled into bed for the night.

Civil War veteran Frank K. "Daddy" Poole was the eighty-two-year-old neighbor of Beverly Owens. The son of a Chicago minister, he enlisted in the Union army as a teenager. After the war, Poole operated a gristmill and raised cattle in the West Plains area. Although bitter memories still remained from the Civil War, individual soldiers such as Poole were respected for their service. On April 13, 1928, the old fellow resigned himself to the noisy fun of the Friday night dance and went to bed.

In addition to the Owens family and Daddy Poole, carpenter Arnold Merk lived with his seventeen-year-old son, Charles, in two rooms on the second floor of the Riley Building.

A senior at West Plains High School, Charles enjoyed the music from the Friday night dances. That evening, Arnold Merk treated his son and his son's friend, Eldon White, to dinner at a local restaurant. After dinner, the boys went on to the Merk apartment, and Merk stopped by his lodge, staying until it closed. At about 10:20 p.m., he parked his car in Davidson's garage across the street from his building and bought a drink at the filling station. As he crossed the street, he noticed a light in Joseph Wiser's garage. Two men were standing inside the building in front of the

windows. Recognizing one of them as Wiser, the carpenter casually took note of the other man, who was about Merk's size—five-foot-eight or five-foot-nine and weighing about 175 pounds—and wearing a hat and a dark suit. Accustomed to seeing people in Wiser's garage, the carpenter didn't pay the men much notice.

Once in his rooms, Merk found the high-spirited boys "fooling around and cutting up." Young Eldon was ready to go home, but Charles convinced him to stay a few more minutes, sitting on the stairway just outside the apartment and listening to the music. Within a short time, the boys returned and the young visitor prepared to leave.

In the Adams Building on the corner of East Main and Walnut Streets, the families of single mothers Lola Dent and Martha Hawkins occupied rooms on the second floor above Bell's Café and Laird Plumbing Company

Soon after Lola Dent and her nineteen-year-old daughter, Hazel, moved to West Plains, Lola secured a job as a desk clerk at the Commercial Hotel, located almost directly across East Main Street from her room. On that Friday night, she thought she had gotten lucky. Many of the men staying at the Commercial, mostly drummers working their southern Missouri sales routes, had eyes for an attractive woman like Lola. That Friday, a

The Arcade Hotel offered the finest accommodations in West Plains. *Courtesy of Toney Aid.*

salesman had requested lodging at the Commercial Hotel, but Lola told him that she didn't have an available room and recommended that he try the Arcade Hotel.

In the 1920s, West Plains boasted several hotels besides the Commercial Hotel, but the largest and most luxurious of all was the Arcade Hotel. Built by Judge W.N. Evans in 1901, the three-story brick hostelry was located less than a block south of East Main Street on Walnut Street. The Arcade offered twenty-two rooms, steam heat, hot and cold running water, electric lights and a system by which guests could signal the desk from their rooms.

After chatting with Lola for a time, the salesman asked her to go riding with him in his sedan. Lola often planned to stay away from home during the Friday night dances because the music kept her and Hazel awake, so she was glad to have the date.

Although her mother liked to go riding with friends, Hazel Dent loved the movies. She was rarely disappointed—an average of eight hundred films was released each year in the 1920s and 1930s. West Plains residents thrilled to the exploits of silent movie stars like Mary Pickford and Charlie Chaplin as early as 1914, when the Famous Theater opened its doors in the Elledge Arcade on the northwest corner of the square.

The Famous Theater apparently did not advertise its movies in local newspapers, but in April 1928, the Royal Theater in the nearby town of Thayer offered *Hawk of the Hills* and *Poker Faces* with Laura LaPlante, *London after Midnight* with Lon Chaney and *The Covered Wagon* and *Denver Dude* with Hoot Gibson. An "Our Gang" film, *One Wild Ride*, accompanied the Gibson movie. Admission was ten to twenty-five cents depending on the day and time and the age of the moviegoer.

Martha Hawkins lived in two rooms on the second floor of the Riley Building with her mother and her four children. After finishing work at Mrs. Peck's store on Washington Avenue that Friday evening, Martha took her sick daughter to the doctor's office.

In 1928, two hospitals served the sick and injured in West Plains. The largest was Christa Hogan Hospital, established in 1920 by Dr. R.E. Hogan and named after his late mother, a prominent civic leader. Located close to the city's eastern boundary on East Main Street, the two-story, red brick building, previously a college and a convent, was surrounded by three acres of manicured lawn.

The hospital was staffed by five physicians: Dr. P.D. Gum, Dr. E. Claude Bohrer, Dr. A.H. Thornburgh, Dr. L.E. Toney and Dr. Hogan. The modern facility included a state-of-the-art operating room, X-ray and laboratory.

The April 12, 1928 issue of the *West Plains Weekly Quill* reported that Christa Hogan Hospital had earned a place on the American Medical Association's list of accredited hospitals, a national honor.

In addition to being on the staff at Christa Hogan Hospital, Dr. Claude Bohrer operated Cottage Hospital in a small frame building on the southeast corner of Minnesota Avenue and Webster Street, on the west side of West Plains. The facility catered to maternity patients and persons needing minor surgery.

The music and merriment of the Friday night dances often kept Martha and her family awake in their rooms above the plumbing shop. That evening, she had to tend a sick child and be up early for work the next morning. At 8:15 p.m., Martha dosed her ailing daughter with medication and climbed into bed. She quickly dropped off to sleep only to be awakened by angry male voices. Such quarreling on Friday nights was not unusual, and Martha was not particularly concerned by it. She later stated that she believed that the men were not in the vacant field behind Bond Hall. Her rooms were located at the front of the Riley Building, and if the men had been in the field behind the adjacent building, their voices would have been muted. She thought the argument might have been in the Wiser Motor Company since the garage's entrance was in the front of the building just west of her apartment, but she concluded that was not likely so late at night. After deciding that the argument was not her business, she rolled over and went back to sleep.

Although the dances at Bond Hall were loved by many local youths, the folks living in the modest apartments and rooms close to the hall were not so keen on the Friday get-togethers. They were all working people of modest incomes who went to bed early and rose early to go about the difficult business of making a living. They had but two choices: stay out late like the Dent women or go to bed and toss and turn until the music stopped and the dancers went home.

Sources

Auto dealer A.W. Gray testified before the coroner's jury about the dilapidated condition of the Ward Building.

An anniversary article dated April 13, 1978, in the *West Plains Daily Quill* written by Jim Cox quoted people who attended the dances fifty years earlier about the drinking that went on during the dances.

Robert Neathery, in his book *West Plains As I Knew It*, page 135, relates the story of Carrie Davis, who owned a local grocery store and sold a suspicious number of cases of alcohol-fortified extract.

The information about Ben Jolly appeared in his obituary in the *West Plains Daily Quill* of April 19, 1928, and came from his death certificate.

Information about sisters Billy Drago and Susan Rogers: the *Quill* of April 18, 1928; the *West Plains Gazette* of April 18, 1928; and the *West Plains Journal* of April 19, 1928. The photo of Billy in a gypsy costume appeared in Toney Aid's book *West Plains, 1880–1930*, page 90.

Movies of the 1920s: "Film History of the 1920s," by Tim Dirks, 1996–2007, www.filmsite.org.

Warren Blakley, Beverly Owens, Charles Merk, Lola Dent and Martha Hawkins all testified before the coroner's jury about their activities on the day of the explosion.

History and facilities at Christa Hogan Hospital: the *Quill*, April 12, 1928.

J.M. "BABE" WISER

MAN AT THE CENTER OF THE FIRESTORM

Joseph Marion "Babe" Wiser rented the ground-floor garage space from Mrs. Leland Ward less than a year before the explosion. Although the building was shabby, the old place did have advantages: a sturdy back door and a large single door in the front through which Wiser could drive vehicles into the interior that served as showroom and garage. According to his employees, Wiser was so conscientious that he insisted that the back door be kept locked even in the daytime.

The garage was roomy, fifty feet deep and the full width of the building. Cars of that vintage were much smaller than today's models, and Wiser often parked as many as twenty vehicles in the garage overnight. The workbench, positioned against the back wall, was convenient for his mechanic, James Jewell, to spread out tools and parts. Two windows in the rear south-facing wall looked into the vacant field behind the buildings on East Main and behind the Arcade Hotel and Ridgeway Dry Cleaners on Walnut Street. An interior stairway on the west side of the garage toward the back of the building led to the upper floor where Mrs. Ward rented out residential rooms and to the commercial space referred to as Bond Hall. Wiser used the small closet, tucked under the stairway, for storing parts.

That Friday, letters from creditors in Wiser's pockets proved that his fledgling General Motors dealership, offering new Oakland and Pontiac vehicles and used cars, was struggling. However, business had been better in the last few months, and he was slowly repaying his debts. Wiser's immediate worry was that General Motors was pressing him to pay for or return $200 in parts he had bought from the corporation. He had sold

some of them, but he didn't have enough cash to settle his bill. He had directed his mechanic to box up the remaining new parts, along with some defective parts, to return for credit. Wiser had planned to send them back to GM on the train that evening.

Three months earlier, General Motors had threatened to cancel its contract with Wiser and repossess its 1927 Oakland, the only new car he had in stock. However, Wiser could have continued to buy and sell used cars because dealing in used vehicles, while not as prestigious as selling new cars, was still a lucrative business in 1928. Wiser had completed two sales in the past few days, and he was optimistic about selling another vehicle. Ida Lee, a divorcée, had assured him that her brother was wiring her the money to buy a car. If he could sell Lee a car, the sale would give him cash to help square his debt with GM.

Wiser had moved his wife, Clara, and their two boys—fourteen-year-old Paul and five-year-old Roscoe—into a large white house just across the railroad tracks on Grace Avenue eleven months earlier. His daughter, Clara Vivian, had married Irvine Barton and settled near Wiser's oldest son, Herbert, and his wife, Essie, in Alton, Missouri.

Leonard Fite, a salesman hired by Wiser in April 1928, lived with the Wisers for a short time, and he enjoyed the family. "They got along awfully nice," he testified to the coroner's jury after the explosion, "nice as I ever saw a family."

Born on a farm five miles east of Alton in 1881, Joseph married fifteen-year-old Clara Newberry in 1904. About 1922, the Wisers moved to Oklahoma and later to Webb City, Missouri. One of his ventures was a telephone exchange that he expanded, updated and sold for what was rumored to be an impressive amount of money. Some said that Wiser's profit was $10,000; others said it was as much as $30,000.

Wiser initially entered into the automobile business with A.W. Gray, but in May 1927, after General Motors named Wiser its sales agent, he rented space in the Ward Building. Despite being business competitors, Wiser and Gray remained friends. Gray later testified that Wiser didn't know much about automobiles but that he had been smart enough to hire an experienced salesman and mechanic to assist him. Automobiles were fast becoming the lifeblood of America, and Wiser wanted to be in on the ground floor of the industry.

Leonard Fite had moved from the Wiser home after both Clara and Roscoe fell ill with influenza. That Friday, Fite was suffering with a toothache, and he asked to leave early. A new salesman, Wayne Langston, had started work

that morning, and Wiser was sure they could handle customers. He told Fite to go home to his room at the Baltimore Hotel.

About noon, Wiser visited Eugene Oaks's real estate office, where Mrs. Lee worked. As Wiser was leaving the office, he ran into the businessman returning from lunch. They exchanged pleasantries, but Oaks was concerned about the attention Wiser was showing to Lee because she had confessed her affection for Wiser to her boss some days earlier. Oaks warned his secretary that Wiser was a married man and that her interest in him was unseemly. Oaks reported his conversation with Mrs. Lee to the coroner's jury after the explosion.

"I wouldn't act simple," he had admonished her. "He's a married man."

"Is it any harm for me to like him?" she asked.

Oaks paid Lee just one dollar per day, and that money supported her and her two sons, Andrew and Sammy, who lived with her. Another married son lived nearby. Andrew worked in the town's bakery, and Sammy helped out when the baker needed him. Oaks was sure that Lee did not have the resources to buy the Oakland car that Wiser had been showing her.

"I did not believe that Mrs. Lee was financially able to buy a car, even though she said she had a brother who would buy it," he told the jurors. He wondered if Mr. Wiser was aware of Lee's true financial condition.

Oaks was also concerned about the woman's sudden appearance at the Assembly of God Church where Wiser and his family attended services and where Mr. Oaks sometimes worshipped. He said that he had observed Wiser's friendliness toward Mrs. Lee, and he believed the man's attention toward her was no different than the affable sociability he showed to everyone.

After his visit to Mrs. Lee, Wiser stopped by Carac Davidson's garage, where Carter Johnson loaned him a gasoline can. Johnson said that Wiser often borrowed the can and always promptly returned it. Just a short distance away, Wiser stopped at the Standard Oil Company to buy thirteen gallons of gasoline. Employee Sanford Palmer put five gallons into the gas can and an additional eight gallons into the tank of the car Wiser was driving.

On that Friday, Joseph and Clara's son Roscoe was ill with influenza, and Clara was busy tending the boy when her husband came in for lunch. Before returning to the garage, Wiser planted some corn and beans in his garden, telling his wife that he wanted to get the seeds in the ground before the arrival of the heavy rain that threatened in the distance. Outdoors, he and his son Paul discussed the upcoming community-wide spring cleanup campaign sponsored by the city. The family later detailed a conversation between Paul and his father to a local newspaper reporter.

"We can't clean this place up to look like anything with them here," said fourteen-year-old Paul pointing at the used cars that Wiser had parked about the place.

"Son, I'm going to take those all down to the shop. I'll come out and get some of them this afternoon," Wiser replied.

While Wiser was away from the garage, a heavyset middle-aged man with a black moustache, driving a Pontiac, stopped by. He told mechanic James Jewell that he was just driving through and could not wait for Wiser. Jewell did not bother to get his name.

By 3:00 p.m., Wiser was back downtown. He paid a small bill at Bell's Café and chatted a bit with James Bell. From the café, he walked to the bank, where cashier Howard Kellett reported that he "drew paper." The banker stated that Wiser was in good spirits. However, half an hour later, Warren Blakley spoke to Wiser in his cream station on East Main Street: "He acted funny, like he was worried about something. I tried to talk to him about cars, but he didn't seem anxious to talk. In fact, he didn't answer me."

Keeping his promise to his son, Wiser returned home with mechanic Jewell to pick up one of the used vehicles parked at the house. While home, he checked on the welfare of his youngest son, telling Clara that so long as the boy was doing well, he would go on back to work.

At 4:40 p.m., Wiser visited the courthouse, where he recorded the sale of a Maxwell vehicle to Raymond Workman with Blain Jennings, recorder of deeds. According to Jennings, Wiser was in good spirits, and the two men chatted about the chilly, rainy weather.

David Henry stopped by Wiser's garage sometime after 5:00 p.m. He was sure of the time because he was so excited about the prospect of buying his first vehicle that he left work early. While the young man was examining a Ford Roadster, Wiser received a telephone call. Henry was standing near enough to hear an operator tell Wiser that he had a long-distance call. David Henry moved away to give the man privacy, but he heard Wiser responding only "yes" or "no" to the caller. According to Henry, the caller rang back, and Wiser answered and said "no" several times.

After Wiser ended the second call, he told Henry, "I didn't want to talk to the fool anyway."

When the telephone rang for a third time, Wiser answered and quickly hung up. According to his customer, Wiser was not upset by the telephone calls, and he cheerfully closed a deal with David Henry to buy the Ford.

At about 5:30 p.m., Wiser, Jim Jewell and Wayne Langston drove three blocks north on Washington Avenue to the train station with a package

that included old pumps, car parts, couplings, coverings and pinions to be returned to the Pontiac Division of General Motors. Jewell later testified that he was sure of the contents of the parcel because he had packed it himself, carefully binding it with wire. According to Jewell, an Oakland representative had been in the garage earlier that week to pick up some other parts.

Because of the time spent selling David Henry a car, Wiser arrived at the station too late to catch the express clerk to mail the package. Leaving Wiser and Jewell at the depot to ponder the situation, Wayne Langston walked back toward the square to the Farmers Exchange. He had planned to speak to a girl who worked there, but she was busy, so Langston returned to the home of his aunt on St. Louis Street, where he was staying. He remembered seeing Wiser drop Jewell off at the Baltimore Hotel, located on the southwest corner of Washington Avenue and Broadway Street, and then continue on up Washington toward his garage.

Jewell testified that Wiser dropped him off at the Baltimore Hotel at 6:00 p.m. He was sure of the time because he remembered hearing the "six o'clock whistle" blow. Before going home to Will Riley's boardinghouse, he stopped at Allen's Market and bought some meat for supper. Jewell's brother told investigators that Jewell complained of not feeling well, and he went to bed at 8:00 p.m.

Clara wasn't worried when Joseph didn't return for dinner that evening. He often stayed so late at the garage that she would go on to bed, leaving his supper on the stove. However, he always took his meals at home, and she never failed to leave food for him to eat after a long day of work. Exhausted from caring for her sick child, she slipped into bed and fell into a deep sleep.

SOURCES

Clara Wiser testified to the coroner's jury about their move to West Plains. She also testified to her husband's habit of working late at his garage and about his movements on April 13, 1928.

On April 19, 1928, the *South Missourian*, an Oregon County newspaper, reported on Wiser's life history. Mrs. Wiser denied that the profit from the sale of the telephone exchange was $30,000. Although A.W. Gray testified that he had heard rumors that Wiser had come to West Plains with $30,000, he admitted that he did not know about Wiser's finances.

The *West Plains Weekly Quill* on April 19, 1928, stated the names, ages and home locations of Wiser's family members. The article included an interview

with the Wiser family in which they tearfully denied the assertion that their father could ever take a life because of his religious convictions. They believed that his religion specifically precluded such action. The cited quotations were taken from that article. The information about his returning home for lunch, planting his garden and promising his son that he would remove the used cars from around their home was included in that same news story.

A.W. Gray testified to the coroner's jury about the condition of the Ward Building and about his previous business arrangement with Wiser.

Leonard Fite and Jim Jewell testified about the layout of the building, including windows, workbench, stairway and more and to Wiser's insistence that the rear door be kept locked at all times.

T.E. Wilkey, a representative from General Motors, testified that General Motors was pressing Wiser to return or pay for the parts that had been shipped to him on consignment.

Eugene Oaks testified to the recent sales made by Wiser and his optimism about selling a car to Ida Lee. Oaks expressed his doubts about Lee's ability to buy the vehicle and about his conversation with her concerning her feelings toward Wiser.

The text of the transcript of the testimonies before the coroner's jury of David Henry and his father, Ed Henry, runs together. However, a portion of the young man's testimony described the telephone call received by Wiser.

Mechanic Jim Jewell testified that Wiser directed him to box up the General Motors parts to send back to the company, but they arrived too late at the train station to ship them.

Wiser's salesman, Leonard Fite, testified to the coroner's jury about the time he had boarded with the Wisers. He said he moved to a hotel only because family members were sick with influenza.

Wayne Langston testified to the coroner's jury about his first day of work that Friday, and Jim Jewell testified about his activities on that day.

The testimonies of Raymond Tiner, Carter Johnson, Sanford Palmer and Jim Jewell estimated the amount of gasoline purchased by Wiser that Friday.

Jim Jewell testified to the coroner's jury about the man who came by the garage that day asking for Wiser.

Newspaper articles quoting witnesses to Wiser's activities and the testimonies before the coroner's jury of Leonard Fite, Jim Jewell, Wayne Langston, Carter Johnson, Sanford Palmer, Beverly Owens, Blain Jennings, Edgar Lee Henry, David Henry, Ed James, A.W. Gray, James Bell, Howard Kellett, Warren Blakley and others were used to establish a timeline of Wiser's actions on April 13, 1928.

THE DANCE

At 11:00 p.m., the catchy, mellow notes of "At Sundown" drifted from Bond Hall into the rooms and apartments along East Main Street. The song is a jazz classic today, but in 1928, jazz was a new, intriguingly seductive sound that was all the rage in the clubs of St. Louis and Kansas City. Many preachers and parents decried the popularity of what they called "darky" music, but young people loved it.

Although 11:00 p.m. was the accustomed time for intermission, several of the dancers had asked the trio to play just one more song before the break. Olis Holestine picked up Dail Allen's saxophone and joined the combo in playing the eerily prophetic final song.

High school student Bront Luna lounged on the third step down from the upper landing of the stairway to the second floor of the Ward Building as he waited for intermission. While Bront waited, he chatted with Hazel Dent, who sat next to him on the steps.

Bront's friend Dail Allen, the horn player in the band, had promised to get Bront into the second half of the dance. The Martins relaxed the rules for admission late in the evening and allowed young people without money to enter the dance. At least a few of the early arrivals would leave the hall at intermission anyway. After more than two hours of dancing the Charleston, the Lindy (named after aviator Charles Lindbergh), the waltz and the foxtrot, many would be ready to take a break at Blakley's candy store on the square for an ice cream or a drink.

Bront had peeked into the hall before settling down to wait, and he noted that the trio of musicians had set up just in front of the windows that overlooked East Main Street.

Above: The scorched remains of the saxophone played by Olis Holestine at the time of the explosion. *Photo by Lin Waterhouse. Courtesy of the Harlin Museum.*

Right: Trumpet player Dail Allen with his athletic trophies in 1930. *Courtesy of Dorothy Allen.*

Dimple Martin was at the piano, Dail Allen played the trumpet and Carl Mullins provided the percussion on a "trap drum," a collection of noisemakers that might have included drums, cymbals, wood blocks, chimes, whistles, sirens and tambourines. A talented percussionist, he was often tapped to accompany musical groups in West Plains. That evening, his nineteen-year-old bride, Naomi, had joined him at the Bond Hall dance.

An accomplished musician, Dail Allen was the sixteen-year-old son of prosperous West Plains grocer H.C. "Lum" Allen, who had accompanied his son to the dance. Dail often played his trumpet with local bands, and he was a regular performer during the intermissions at local movie theaters.

Both Mo Ashley and his fiancée, Evelyn Conkin, had moved from West Plains after their high school graduation, but they were back in town that evening for a few days of togetherness and to reconnect with friends. A niece of Mayor Jim Harlin, Evelyn was a gifted artist who worked for Hall Brothers, Inc., creators and distributors of greeting cards in Kansas City. Mo had just pulled up a seat next to Carl Mullins, probably anticipating time

The daughter of a Willow Springs newspaper publisher, Hazel Slusser was a teacher and accomplished pianist. *Courtesy of the* West Plains Daily Quill.

to catch up on events in their lives during intermission.

Hazel Slusser danced the last song before intermission with John Riley. Hazel was a teacher and accomplished pianist in Willow Springs, Missouri. Hazel's father, H.F. Slusser, had been the editor of the *Willow Springs Republican* newspaper for many years. He had relocated his family to Quinton, Oklahoma, a few months earlier, and Hazel had plans to join them after the close of the school year.

Glen Moore had told his companion, Ruby Hodkinson, that they would have to leave at intermission. Maybe Glen was thinking of his girlfriend, with whom he had quarreled, or maybe he dreaded the early

hour when he would have to be at work the next morning. For the last dance before intermission, Ruby had accepted another gentleman's offer to dance, so Glen asked Ernestine Cunningham of Willow Springs to take a whirl around the dance floor. Many years later, Moore would recall some folks joking about the unlucky reputation of Friday the thirteenth, but few of the young dancers believed in the old superstition.

Mrs. Soula Martin, Dimple's mother, was standing off to the side of the room near the front windows talking to Kitty McFarland and Major Bob Mullins. Rumors suggested that the two, both widowed in their first marriages, planned to announce their engagement. The wedding of the two prominent citizens of West Plains promised to be the social event of the year.

Just inside the entrance to the hall, seventeen-year-old Bus Langston was manning the checkroom. He enjoyed sitting in the window of the small room that overlooked the hall to watch the dancers. Spotting a friend across the room, Langston left the checkroom and headed down to the dance floor to talk. John Bates, who had dined with Garrett and Fern McBride before the dance, took his place.

Roy Crain, a clerk in Bohrer's Drug Store on the square, was standing in the hall watching the dancers. Some folks wondered why Crain was alone at the dance since he had a wife and children at home.

William Fitchett, a glass dealer and glazier from West Plains, had brought his wife to Bond Hall. They were observing the dancing from their seats near the front of the hall by the windows that overlooked East Main Street.

Despite the chilly damp of the evening, a convivial group had gathered on the street in front of the Ward Building. Young people loitered about on the sidewalk, while others leaned on cars parked along the street.

Paul Evans had stopped his car in front of the hall and was talking to his friend, Ray Daugherty, through his open window. Evans, the son of a prominent state horticulturist, had studied agriculture and dairying at Missouri State University. He had plans to start a dairy business with his friend Norwood Benning, and the two young men had just brought a herd of registered milk cows to Howell County. Hoping for a ride, Daugherty asked Evans if he was headed home, but the young dairyman said he was going to stop into the dance for a few minutes.

Booksellers Mr. and Mrs. Matt Adams had worked late that Friday evening and at 11:00 p.m. were walking along East Main Street on the way to their home on South Curry Street. Mrs. Adams suggested to her husband that they stop to listen to the music, but Adams, who wasn't much for dancing, told her that he was too tired, and they continued on home.

By 11:04 p.m., the night had turned chilly, with a cold rain beginning to fall, but the people both inside and outside Bond Hall surely believed that the Martins' first dance following the Lenten season of 1928 had been a great success. One minute later, their lives changed forever.

SOURCES

In the April 13, 1978 edition of the *West Plains Daily Quill*, Jim Cox wrote a colorful description of the dance and the dancers' routine of retiring to Blakley's candy store on the square after intermission.

Bront Luna gave a description of people's location in the hall to the coroner's jury. In his April 13, 1978 article in the *Quill*, Jim Cox interviewed Luna, who told Cox that he had peeked into the hall before settling down to wait for intermission.

An account of Olis Holestine playing Allen's saxophone accompanies the scorched instrument on display at the Harlin Museum, West Plains.

The relationship between Mo Ashley and Evelyn Conkin was part of an article appearing in the *West Plains Weekly Quill* of April 19, 1928.

The account of Hazel Slusser's last dance with John Riley was told in Riley's account of the explosion in the *West Plains Gazette* of April 19, 1928. The story of Hazel Slusser's family's move to Oklahoma appeared in the April 19, 1928 *West Plains Journal*.

Carol McInnis, daughter of Glen Moore, told the author that her father and Helen McCallon, who became her mother, had argued in the days before the dance. Moore recalled some folks joking about the unlucky reputation of Friday the thirteenth, according to Jim Cox's article in the *Weekly Quill* of April 13, 1978. Glen Moore's account of his survival and that of his dance partner, Ernestine Cunningham, appeared in Cox's article.

Bus Langston's survival, after he left the checkroom, and the death of John Bates, who took his place, were part of an April 13, 1978 *Quill* article written by Jim Cox that appeared on the fiftieth anniversary of the blast.

The solo appearance of Roy Crain at the dance was the subject of questioning of Mrs. Crain by the members of the coroner's jury.

William Fitchett's account appeared in the April 19, 1928 edition of the *Gazette*.

The information about Paul Evans and Ray Daughtery appeared in Evans's obituary in the *Gazette* of April 26, 1928, and in Daugherty's testimony to the coroner's jury.

The close escape of booksellers Mr. and Mrs. Matt Adams was reported by Jim Cox in the *Quill* of April 13, 1978.

EXPLOSION!

Mr. Pool, who lived on the first floor of the Arcade Hotel, was a cigarette smoker. His sister kept house for him, and she despised the habit. That Friday evening, Pool had retired to the back room of his apartment to enjoy a smoke away from her nagging. After he opened the window four or five inches to admit the air that would clear the smoke from the room, he noticed the strong smell of gasoline. Although his rooms were near the Wiser Motor Company and several other garages, he had never smelled the odor of fuel before that evening. As he extinguished his cigarette, he glanced out the window toward the rear of the buildings facing East Main Street. From his vantage point at the rear of the Arcade, he "had a fair view of the east window of the garage."

"At first, I saw just a faint light over the windowsill," he later testified to the coroner's jury. "I saw illumination from light inside the garage…It kept getting brighter and at last I could see flames above the windowsill. The light in there was from a fire." Within seconds, the flames were lapping at the ceiling of the garage.

"I got my hat and thought I would step out there to look in." Suddenly, Pool was jolted by "the flash of an explosion" that he described as "quick and sharp." "It seemed to me that the wall went up a foot or more and then collapsed. I only heard one blast and then a crash after the blast, all that breaking of glass."

The concussion so violently shook his apartment that Pool and his sister fled for their lives.

Reverend J.C. Montgomery, presiding elder of the Cape Girardeau, Missouri district of the Southern Methodist Church, was in a room at the Arcade Hotel chatting with Bishop McMurry of Fayette, Missouri. Reverend

Montgomery had previously served as pastor of the West Plains Methodist church, and he had enjoyed seeing old friends at the weeklong religious conference that had just concluded. The men were passing the time until they would catch a late-night train home.

"I heard a terrible explosion that almost threw me off my feet," Reverend Montgomery said.

After the explosion, the men rushed out onto the veranda. To their horror, they spotted a young man and woman hanging from a piece of wreckage too high for rescuers to reach. Montgomery observed that the two seemed so close to him that he could easily recall the suit the man wore. The girl was practically nude, and huge gashes of torn flesh and ugly black burns covered her body. He heard her scream, "We will be burned to death."

According to the clergymen, the man tried to remove his coat, apparently to cover the woman, but suddenly a huge burst of fire devoured the couple, and they disappeared into the inferno.

B.N. Cade of Kansas City was relaxing in his room at the Arcade Hotel. His window provided a view of the rear of the businesses along East Main Street. Suddenly, the force of an explosion threw him from the chair in which he had been sitting:

> At once there were flames. The blaze was the most unusual I ever saw. In the center seemed to be a pale green circle like a pinwheel in motion. At the edge, the green became a darker hue all surrounded by yellow flames.
>
> I could see some of the men and women running around and others lying under the timbers. I had been thinking only a few seconds before, as I looked from my window over into the dance hall that the young people there were certainly having a good time and enjoying themselves.
>
> I ran down in the street and there were some other men there who had been attracted by the explosion, but we were unable to do anything to save the imprisoned people.

In Mountain View, Missouri, twenty-six miles north of West Plains, Chester Arthur was locking up his restaurant. His watch read 11:01 p.m. when he heard an explosion in the distance.

J.E. Threlkeld of Brandsville, thirteen miles east of West Plains, thought he felt an earthquake at about 11:00 p.m.

C.A. Wright, the publisher of the *Oregon County Times Leader* newspaper, had joined some friends at Peach Center, eighteen miles east of West Plains. He described the loud report that he and others heard as "sounding like a bomb."

Bront Luna had been sitting on the steps of the stairway leading up to Bond Hall with Hazel Dent. The explosion launched the entire step structure on which they sat into the air. It teetered in mid-space a moment and then swung back toward the building. Like a man surfing a great wave in a monstrous storm, Luna rode the motion of the stairway to its apex and leaped into the black void for escape.

Glen Moore was dancing with Ernestine Cunningham when he heard a loud noise and felt a hard blow to his leg. The force of the explosion blasted him up and up and up into the rainy nighttime sky. Ernestine was still clinging to him as the two fell back down into the remains of Bond Hall.

Struck unconscious by his landing, Moore awoke under a protective shell of debris. As he fought to free himself from the tangle of wire, beams, bricks and glass, he heard Cunningham screaming for help. She was trapped under heavy timbers, and flames were breaking out all around her. Stunned and unsteady, Moore pulled the beams from Cunningham's broken body, lifted her into his arms and looked around for a means of escape. Through the smoke and flames, he spotted the gasoline pumps of Davidson's garage on the north side of East Main Street. He fought his way toward them, falling several times before he reached the safety of the street and collapsed. All around them, Moore and Cunningham heard the horrific cries of the other dancers, trapped under the fallen building that was quickly incinerated by the firestorm.

"I remember as I was taking Miss Cunningham out I kept thinking I must go back and help the others, but soon things began to get hazy and then the next I remember I was in the hospital," said Moore.

"Mr. Moore and I were dancing near the center of the hall when the explosion came," said Ernestine. She spoke to a *Quill* reporter as she lay on a cot in Christa Hogan Hospital. "We were thrown up into the air and when we came back down my feet and limbs were pinned down under wreckage. I was powerless to move. Mr. Moore freed himself, and although the flames were bursting around us everywhere, he remained with me, working until he removed the weight from my feet and helped me up. I was unable to walk and he carried me out. I can never repay him. I owe my life to him, for had he left me I could never have escaped."

John Riley and Hazel Slusser heard the deafening roar of the explosion as they were dancing. "It was a terrible experience," Riley told a *West Plains Gazette* reporter. "When I recovered my senses after the explosion, I found myself covered with debris and saw fire coming. I heard people screaming all around me and fought my way through the fire and luckily came out onto the street." He had no idea what had become of Hazel.

In 1917, John Riley and Nellie James Murphy (second couple from left) were partners in a dance at the Catron Opera House. Riley survived the Bond Hall explosion; Murphy did not. *Courtesy of Toney Aid.*

Drugstore clerk Roy Crain shared the terrible moments after the explosion with the *Gazette*, which reported his account on April 19, 1928:

I was just watching them dance. The floor lifted upward with us. Women screamed, men prayed. Then, we were blinded by the flash of the fire and began falling downward. Many dancers went down clasping their partners tightly in their arms. I never will forget the horrible looks on their faces.

Finally the seemingly endless fall came to an end. We had reached the bottom and all around us bricks and heavy timbers were falling; flames were crawling around us. We were helpless, held down by the weight of the debris. My legs were pinned down by a girder. I had been struck on the head by falling materials. I just had resigned myself to what was coming when I looked a little way over and saw a girl hanging over a piece of timber.

My eyes were on her when the flames struck her. I saw her face and heard her scream. "My God," I thought. "I can't die like that." I struggled and finally was successful in freeing my legs. I crawled through the fire then to safety. It was a matter of strength getting out of that. I believe that is the reason more men escaped than women. And I believe more would have escaped had they not chosen to remain with their wives or partners.

The Fitchetts, who were seated near the front of the hall, also escaped death. "I felt like I was in a dark room when I heard the crash," said Fitchett. "Then, it was like somebody taking a flash light picture. Then, it seemed we were sailing away. We shot up and came down. I could hear my wife calling for me. It seemed an age until I could free myself. There were bricks and timbers all over me. After I got free, I pulled my wife out."

Mo Ashley didn't hear the explosion because the beating of Carl Mullins's trap drum was so loud. "I just felt myself going up and then coming down. I remember hearing a woman screaming, 'I'm burning up.' My feet got hot. Then, I crawled out from beneath the wreckage and took two or three steps. Somebody took my arm and I fainted."

Dail Allen recalled the red color of the explosion and the feeling of flying upward for what seemed an eternity and then tumbling in the air as he plunged back into the rubble. He lost consciousness, and he awoke to find himself on the sidewalk in front of the ruined Ward Building. An iron pipe protruded from Allen's back, and rescuers thought he was dead. He lay dazed and unable to move.

Bront Luna, who had leaped from the stairway, landed next to Allen. To his shocked horror, close to them lay the exquisite, red-haired Dimple Martin, crushed by the piano she had been playing. The dazed Luna tried unsuccessfully to lift the piano from her lifeless body. Then, realizing that Allen was still alive, he dragged his friend by the arms across the street to the front of Davidson's garage. Allen looked back to see the front wall collapse onto the spot where he had been lying. He owed Bront Luna his life. In one of so many odd ironies of the explosion, Allen's shoes had been blown from his feet, but he still held his beloved trumpet.

Martha Hawkins thought that she heard three explosions, but she could detail just two. The first awakened her, and she leaped from her bed in fright. She stated that the second, and more violent, explosion occurred as she was trying to get her dazed and drowsy mother and children to evacuate their devastated rooms. She herded her terrified family toward the exit, where she suffered a shock.

"The stairway was gone. Just a plank was left and we got down on that," she told the coroner's jury.

The Adams Building, where the Hawkins family lived in two second-floor rooms at the front of the building, had been destroyed by the blast.

"Where the girls were—it was all gone," Hawkins said.

Hours later, when she appeared before the coroner's jury, she still seemed in shock. "I can't tell you much what happened," she said. "I don't know."

At the moment of the explosion, Lola Dent and her gentleman friend were sitting and talking in his car alongside Highway 63. She estimated that she and her acquaintance had been parked about three miles from West Plains when they heard the sound of the blast. They immediately headed back into town, where they discovered the Ward Building "all in flames." In a panic, Dent began searching for her daughter. "Just as I got to the hotel, she ran up to me," she said.

Hazel told her mother that she had been sitting on the stairs with Bront Luna when the building exploded, and she had been thrown clear of the destruction.

Lola indeed considered her Friday the thirteenth to be fortuitous:

> *I was lucky that man asked me to go riding with him. Just saved my life. I have other friends I go riding with very often, especially on nights they dance because I can't sleep, and my little girl goes to the show. You see, this is just a wall between us and the dance hall. We take those nights to do our going because we can't sleep.*

Beverly and Hattie Owens and their four-year-old daughter were asleep in their rooms in the Riley Building behind the cream station.

"We were awakened by the explosion. The whole earth trembled. The building shook. I told my wife who was sitting up in bed there must have been a tornado. She screamed that we were lost. Then flames began to creep up, in and almost touch us. I took the baby and protected her as best I could, put an arm around my wife and started to set out. We finally made it."

When the Owens family reached the street, Mr. and Mrs. Blakley, owners of the cream station, rushed up to help. Mr. Blakley ran to get his car, while Mrs. Blakley wrapped her coat around Hattie and her child.

"They took us home and got us some clothes," said Beverly Owens.

Elton White had enjoyed his evening with his friend Charles Merk. Seventeen-year-old Elton worked for Laird Plumbing, and Charles was a high school student. After Charles's father, Arnold, took them to dinner, the boys returned to the Merk apartment, while Mr. Merk went on to his club. The boys listened to the music in Bond Hall as they sat on the stairway that provided entrance into the upper floors of both the Ward and Riley Buildings, a prime viewing spot from which to watch the dancers arriving and to hear the sounds of merriment in the hall. At a few minutes after 11:00 p.m., White departed for home.

"We always kept the door locked during dances, and my boy unlocked the door and let the White boy out," Merk told the coroner's jury.

Just after he let the door open and shut the door, the blast came.

Just seemed to be—it was a big upheaval and quick as that everything went down, a rumble of bricks and timber. You couldn't hear yourself think. Immediately after the rumble, the fire started. I sat about ten feet from the wall. I just sat down when it happened. First thing I knew I was on my hands and knees and when I got up, I looked out to see where my boy was. I saw the fire coming to, and then the fire came quick.

[The walls] had come down [a] little up in this shape against [the] bank building. In the center where [the] stairway was, it was down, and that left an opening between the roof and the floor. I[t] was on[ly] about three or four feet, but it left the floor down low enough that I crawled out of the lower window on the north side. I didn't come out the window but [I came out on] the first story.

Stoically, Merk told the jurors that he identified the body of his son from the clothing he had been wearing when the force of the explosion struck him.

"I was about five or six feet down the hall from Merk's door, when the crash came," said Elton White.

He [Charles Merk] was standing in the door as I left, but I did not see him after the blast. When the second floor went down I was pinned under wreckage and was unable to get out before the flames reached me. I finally got free and dashed out. My clothing was in flames and some boy in the street, I think it was Donnie Chapin, helped me tear them from my body. I then rushed to my home here just around the corner.

Rescuers later described young White standing on the sidewalk in front of the flaming building. His entire body was burned and bloody, and he was wearing only his shoes. The smoldering remains of his underclothing hung around his feet. He fought off the men who tried to aid him and ran to his home on South Hill Street. When his shocked family members asked him what had happened, he could say only, "The dance hall blowed up."

Witnesses told authorities of observing a naked boy fleeing the scene of the explosion. Some days elapsed before Elton White was identified as the terrified and badly injured victim seen running through the streets of West Plains.

On April 19, 1928, the *Gazette* summed up the tragedy: "It was some terrible force that raised the floor of the dance hall into the air to fall twelve feet below and blew out both ends of the building. The force of the explosion also destroyed the buildings on both the east and west sides and scattered fire, death and destruction into them."

SOURCES

Mr. Pool (first name unknown) gave his account of the explosion in his testimony before the coroner's jury. In the transcript, his name is spelled both "Pool" and "Poole." Pool described seeing the fire through the east window of Wiser's garage; however, both Leonard Fite and James Jewell reported that the building had windows on only the south side.

Reverend J.C. Montgomery's account of the explosion appeared in the April 19, 1928 *West Plains Gazette*.

B.N. Cade's account of the explosion and the reports of hearing the explosion from Chester Arthur in Mountain View, J.E. Threlkeld in Brandsville and C.A. Wright in Peach Center were reported in the April 19, 1928 *Gazette*.

Bront Luna's account was taken from his testimony before the coroner's jury and an article in the April 19, 1928 *Gazette*.

Jim Allen, son of Dail Allen, related to the author the injuries to his father and his rescue by his friend in a telephone interview on May 17, 2009.

The accounts of Glen Moore and Ernestine Cunningham appeared in the April 19, 1928 issue of the *West Plains Weekly Quill*. Glen Moore also spoke to *Quill* reporter Jim Cox for his article in the April 13, 1978 edition of the newspaper.

John Riley told his story to the April 19, 1928 *Gazette*.

Roy Crain's account appeared in the *Gazette* and the *Quill* on April 19, 1928.

The accounts of Elton White, William Fitchett, B.B. Owens and Mo Ashley appeared in the *Gazette* of April 19, 1928. Arnold Merk testified before the coroner's jury, and his story was also reported in the *Quill* of April 19, 1928.

Dail Allen's account of the explosion, as told to Jim Cox, appeared in the *Quill* of April 13, 1978. John Harlin related to the author Allen's account of his surprise when he landed on the sidewalk still holding his trumpet.

Elton White told his story to the April 19, 1928 *Quill*.

Martha Hawkins, Lola Dent and Beverly Owens testified before the coroner's jury.

HORROR AND HEROICS

At 11:05 p.m. on April 13, 1928, Floyd Arnhart was asleep in his home three blocks from Bond Hall. A tremendous blast threw him from his bed. He grabbed some clothing and ran outside. The sky was alight with fire, and he dashed to the scene:

> *I'll never forget the agonizing shrieks of those trapped by the falling walls. It was virtually an earthly hell.*
>
> *I could hear the cries of women and men calling for help. I heard one feminine voice call out in an agonized shriek, "Oh, mother, help me." I pitched in to work with three other men in rescuing bodies. The shrieks died out in five minutes. Everyone, in my opinion, was dead in ten minutes after the blast.*
>
> *One of the men, who saw the explosion, said that the roof of the structure seemed to have lifted into the air fully 200 feet by some unseen force. It then floated back and with a crash, splintered on the trapped bodies.*

Constable Els Seiberling, the night-duty policeman, was standing in front of Atteberry's five-and-dime on the north side of the square when he was knocked off his feet and showered with glass from shattering windows in the buildings surrounding the square.

"It was an awful explosion. Powerful. Whatever it was, it raised me off the ground and rolled me around," said Seiberling.

Edward B. Toler and Aubrey W. Landis were working late at the Kellett-Landis abstract office on the square.

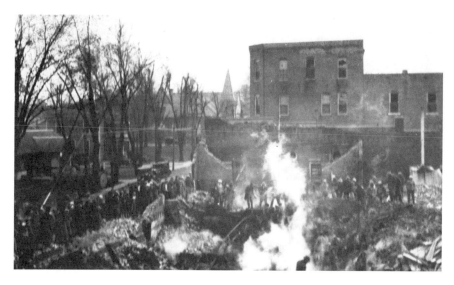

Crowds of shocked onlookers encircle the site of the explosion. *Courtesy of the* West Plains Gazette.

"Suddenly there was a terrific explosion. It was low and muffled but it lasted a second or more, and there was a tremendous volume and force behind it," said Toler to a reporter from the *Gazette*. "It wasn't like the sharp crack of a gun—but low at first and roaring higher. We thought the bank safe had been blown and ran out on the street. Everywhere on Court Square broken glass littered the sidewalks before the stores. A moment later we rushed around the corner to find what had happened."

Seiberling, Toler and Landis were shocked to discover that the roof, front walls and second story of the Ward Building had been demolished by the explosion.

"Flames leaped through the whole structure as if they had been burning an hour," said Toler. "I remember thinking that it couldn't be—all those fine young people—and then that the whole row of buildings and everything was lost."

Toler estimated that only ten seconds had elapsed from the blast until he arrived at the scene where flames were already leaping from the wreckage of the buildings. He saw a man hanging from an electrical wire and three men dangling from a beam at the front of the building who jumped to safety.

"I didn't see a body or a face or any living thing in the mass of debris at the front of the building," said Toler.

"I could not get close because of the intense heat," said Seiberling to the *Gazette*. "The men and women were screaming and I could hear some of them moaning and praying. All were pleading for help but I couldn't get to them."

While Seiberling ran to the courthouse to summon the fire department, Toler, Landis and Mike Fitzgerald, local tinner and plumber, waded into the ruins of the buildings. They dragged out five living people, one of whom was elderly Civil War veteran "Daddy" Poole. Landis freed William Fitchett, the burly glass man, and then the two men worked together to free Mrs. Fitchett. The men hurried around to the back of the building, but bricks and timbers were piled so high that they could not pull anyone from the wreckage, but they did hear the terrible shrieking cries for help from the trapped victims.

"Now, I guess they were unconscious cries of agony," said Toler, "for there were no shouts for help, and no intelligent words to guide us."

Fire department volunteers arrived within minutes, and they threw up ladders and pulled people from tottering walls. However, they were too late to aid most of the victims of the explosion.

"They were all burned up, though. I guess before we got two streams of water playing on the fire," said Seiberling. "Even while the bricks were hot we began searching the ruins in the hopes that possibly we could find someone yet alive."

"The cries of the people buried under the blazing debris—people we knew we couldn't help—will remain with me until I die," said W.H. Evans, a traveling salesman from Chicago.

He and three other salesmen were standing on the street in front of the Commercial Hotel when the explosion occurred.

"Suddenly, there came a tremendous blast that sounded like a dynamite bomb," said Evans. "Plate glass all along the street was shattered and the ground trembled."

"They didn't have a chance. The front of the building was blown out and the upper floor collapsed," Evans continued. "They were hurled into a blazing inferno from which there was no escape."

Evans and his fellow salesmen helped the fire department raise a ladder to a second-floor window to rescue four men who were trapped in the flames.

Lester Blackiston, a West Plains High School football star, was nearby at the time of the explosion. After racing to the scene, he saw the young pharmacist Garrett McBride frantically trying to extricate his wife, Fern, from beneath the fallen debris. Young Blackiston worked his way through the wreckage, helped pull the heavy timbers from the woman and carried her to safety.

Sixteen-year-old Joe Aid Jr. was asleep in his home on Leyda Street, one block south of East Main Street, when the sound of the explosion awakened him. An amateur photographer, he grabbed his camera and ran toward the

smoke and fire. His photographs, taken at first light on Saturday morning and broadcast around the world, documented the disaster.

Harry Zorn, editor and publisher of the *Gazette*, was standing on the railroad tracks about two blocks north of the Ward Building at the time of the blast. He judged that the debris was blown "two or three times as high as the West Plains Bank building" located at the corner of East Main Street and the square. He dashed to the scene where he witnessed a steady stream of rescuers pouring into the area. Assistance arrived on foot, on horseback and in cars. Practically everyone in West Plains had heard the sound of the explosion, and hundreds of people converged on the square to offer help.

All of the rescues were completed in a matter of minutes because the raging fire overtook the remains of the three buildings, destroying everything and everyone trapped in its path. Many of the survivors, like band members Carl Mullins and Dail Allen, who were seated in front of the windows facing East Main Street, and Bront Luna, who had been sitting on the stairs on the west side of the hall with Hazel Dent, were thrown clear by the force of the explosion.

Some persons—such as Glen Moore, who carried Ernestine Cunningham through the flames and out onto East Main Street—sustained injuries but survived to tell a tale of unimaginable terror. Because the front of the Ward Building had been destroyed by the blast, the path of escape was open—except for the fire that quickly enveloped the site.

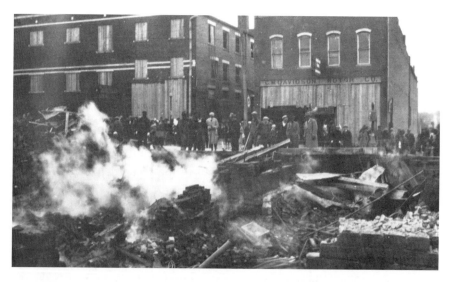

The smoldering remains of the 100 Block of East Main Street, looking north toward Davidson's Motor Company. *Courtesy of the* West Plains Gazette.

Many of the dancers who survived the force of the blast and were not trapped under bricks and timbers fled away from the flames, stumbling toward the back of the building. The rear wall had not completely collapsed, and it leaned precariously at a sharp angle toward the south. The only means of evacuation from the south side of the building was to scale the wall. Rescuers watched in horror as person after person, burned and bloody, attempted to climb the tilted surface of the wall only to slide back down into the flames.

Survivors and rescuers alike wandered around the area dazed and disbelieving. Shivering in the night's cold drizzle, the injured quickly slipped into shock and delirium. Cars parked around the square were commandeered to rush the injured to Christa Hogan Hospital, where the staff shifted into disaster mode and summoned help from off-duty doctors, nurses and lab personnel to treat the injured. Many of the survivors sustained life-threatening injuries, including broken bones and internal injuries; almost all suffered from shock, lacerations, bruises and burns. Only Bus Langston, who was less seriously injured, was sent to Cottage Hospital.

The throng of volunteers and distraught family members converging on the square created pandemonium in the cold, rainy darkness. Policeman Els Seiberling was the first official on the scene, but Sheriff Fred Juren, Chief of Police J.A. Bridges and Fire Chief Jake Palmer soon arrived to direct the rescue efforts. Mayor Jim Harlin was out of town at the time of the explosion, and he hurried home when told the news.

Braving the still-blazing blast site, men ripped away fallen debris with blistering hands in a vain attempt to locate survivors. Those people physically unable to search for victims served in other constructive ways—City Commissioner Earle Armstrong brewed and served coffee to the exhausted rescuers. Tractors and trucks owned by both the city and private citizens were used to drag away iron beams and heavy timbers and to demolish partially standing walls that hindered the recovery work.

Electrical power was out for blocks around the square. At first, the flames illuminated the scene. As they died away, automobile headlamps and battery-powered torches served to light the searchers' way. Superintendent of Utilities W.P. Britain organized workers to cut the ends of live wires away from the wreckage and to quickly restring broken power lines. Once electricity was restored to the telephone exchange located only one hundred feet from the disaster area, exchange manager Jerome Boyer mobilized his operators to handle the massive volume of calls coming into West Plains

Billy Drago, shown here, died with her sister, Susan Drago Rogers. *Courtesy of the* West Plains Daily Quill.

requesting information about the disaster, as well as outgoing calls to family and friends to tell them of injuries and deaths.

Billy Drago, manager of the Western Union in the Riley Building, died in the blast. The telegraph office was temporarily relocated to the waiting room of the Frisco railroad station and then to space within the Arcade Hotel. An army of telegraphers handled the volume of messages of sympathy pouring into the city. Even laboring around the clock, the office struggled to receive, transcribe and deliver the expressions of sorrow and frantic inquiries from distant family and friends who feared that their loved ones had been at the dance. The telegraphers' most difficult task was sending notification of deaths and injuries from grieving families to distant relatives.

Volunteers rushed to Christa Hogan Hospital with quilts, blankets, sheets and pillows. Families, friends and complete strangers offered to change beds, carry bedpans, scrub floors and hold the hands of distraught patients. In Springfield, the Red Cross offered to send "two high powered automobiles with doctors and nurses to West Plains at once if they were

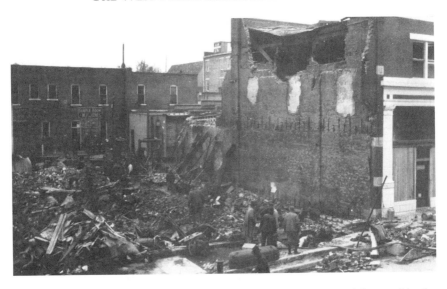

The Riley, Ward and Adams Buildings were leveled by the explosion, and the east side of the West Plains Bank was heavily damaged. *Courtesy of the* West Plains Gazette.

needed," and doctors and medical personnel flooded in from surrounding towns to provide assistance.

The state-of-the-art facility and the medical professionalism of the staff at Christa Hogan Hospital was such that only one of the people pulled alive from the flaming buildings that night died. Nineteen-year-old Elbert White, a bus driver from Doniphan, Missouri, who had attended the dance with his brother David, expired from severe burns one week after the explosion.

All three buildings in the 100 Block of East Main Street were totally demolished. Almost every window in the businesses on the square, including those in the courthouse, and down Washington Avenue was shattered. The Arcade Hotel on Walnut Street sustained damage, as did the West Plains Bank on the corner of the square and East Main Street. Langston-Pease mercantile, located across East Main Street from the bank on the opposite corner of the intersection, was also damaged. Davidson's motor garage, A.W. Gray's motor garage and the Commercial Hotel, all situated on the north side of East Main Street, required serious repairs. Eventually, the wood-frame Gothic courthouse, severely jolted on its foundation, would fall victim to the blast. While the physical damage to the West Plains business and judicial district resulted in huge financial costs, the loss of life devastated the community.

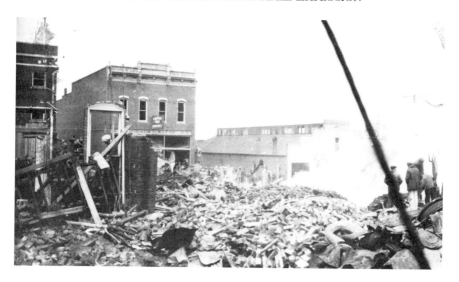

Witnesses believed that trapped victims died within minutes of the devastating explosion. *Courtesy of the* West Plains Gazette.

The first body removed from the wreckage was that of Paul Evans Jr., who had hoped to raise a herd of fine purebred cattle. He had been standing outside the Ward Building talking to friends when the blast erupted. He was found lying facedown on the sidewalk, covered with debris. The second discovery, Mrs. Soula Martin, was found in the remains of the stairway to Bond Hall. Her daughter, the beautiful and accomplished Dimple, died on the sidewalk outside the hall, crushed by the piano she had been playing, and rescuers soon removed the body of their husband and father, Robert Martin, from the ruins.

In an odd sidelight, in the days following the explosion, Bob Martin's new Model A Ford coupe, crushed and burned, became an object of interest to the curious visiting the explosion area; many of them had not seen the newest in the Ford line of vehicles.

Survivor Bus Langston would forever recall that he had been sitting in the window of the cloakroom overlooking the dance floor until just before the explosion. After he left the spot to talk to a friend, John Bates had taken his place. Bates died in the explosion.

Garrett and Fern McBride owed their lives to high school football player Lester Blackiston, who helped Garrett free Fern from the fallen timbers and carried her out of the wreckage. Garrett recovered from his injuries quickly, but Fern remained in Christa Hogan Hospital for months with four fractured vertebra in her back and a crushed ankle. When Fern arrived at

the hospital that evening, Dr. Hogan enlisted seven men to help him move her. To minimize the pain of her broken back, the men entwined the fingers of their hands to lift and gently carry her to the X-ray laboratory.

The remains of Kitty McFarland and Bob Mullins were found close to Mrs. Soula Martin. The three friends had been chatting together at the front of the hall at the moment of the blast.

Bob Mullins died along with Lev Reed, the brother of his deceased wife. Reed's date, Juanita Law, and her cousin, Ruby Hodkinson, mother of three-year-old Clifford, also died. Major Mullins's brother Carl, the trap drummer, was blown clear of the debris, but Carl's bride, Naomi, was found in the rubble. Carl identified the body of his young, pregnant wife by the locket he had given her.

Carl Mullins, the drummer, identified the body of his wife by the locket he had given her to celebrate her pregnancy. *Courtesy of Carla Mullins Burns.*

Throughout the night, Richard M. Jones, Grover Klain, Lee Dudley and Haydon Morton had manned a fire hose at the rear of the block of burning buildings. Not until the fire was almost extinguished in the early morning hours did they find the body of Joseph Wiser in the field behind the ruins.

He was lying facedown in a stretched-out position about fifteen to twenty feet from where the back door to his business had been and east of the center of the Ward Building. His head was pointed in a northwesterly position, and his feet, legs, right arm and shoulders were buried under bricks and a table. Klain testified that the men removed twenty to twenty-five bricks from his body before they rolled him onto his back. Although Jones and Klain saw no indication of fire around his body, Morton reported seeing burned timbers nearby. Wiser's clothing was not burned or singed.

When the men moved the body, papers fell from its pockets. Dudley picked them up and read Wiser's name on one of the sheets. Not until then did they realize it was the body of the auto dealer. Jones recalled that Wiser's face was dirty but not smoky and "looked like it had been cut up." Klain, however, did observe ashes or smoke on Wiser's face and remembered that Wiser's leg was broken. Morton said that Wiser's face "was bloodier than anything" and streaked with dirt. He remembered Wiser's prominent front teeth were smeared with blood. In the days following the explosion, the observations of these four men would become important clues to the source of the disaster.

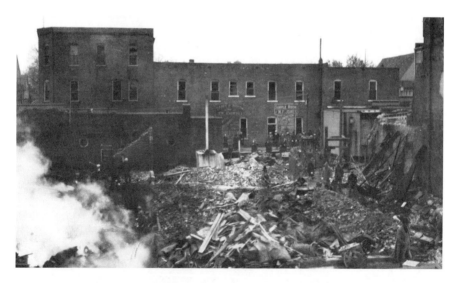

On the morning following the blast, workers sifted through the ruins, searching for remains of victims. *Courtesy of the* West Plains Gazette.

The most painful losses of all would be borne by the families of the people whose bodies were so badly charred that they could not be identified. Edward Eddy, reporter from the *Springfield News*, wrote of one distraught father unable to locate the body of his son: "In Red Cross headquarters a father is saying, 'Why should I take some bit of charcoal and call it my son? They cannot identify him. Then let them bury all together. It is better.'"

Icie Risner's family suffered through a frantic search, first through Christa Hogan and Cottage Hospitals and then through the McFarland Undertaking Company and the Davis-Ross Undertaking Company. Her parents, Mr. and Mrs. J. William Risner, and her sister, Lydia, all came from Thayer in search of Icie. Alvin Garner, who had convinced the young teacher to turn around on her way home from the Methodist Church conference and accompany him to the dance, was also missing. The Risners did find Garner's car parked near the square. In it they found a ring that Icie had always worn and traces of blood. Icie's sister Lydia testified to the coroner's jury that the ring was so tight that her sister always had trouble removing it from her finger. Boyd Gray, another friend of Icie and Garner, survived the explosion, but he could shed no light on why the young woman's ring was on the floor of Garner's car.

The blood in the car was easily explained. Autos of the 1920s had no security devices to protect them from use by persons other than their owners. Desperate rescuers had loaded victims into commandeered vehicles and conveyed them to Christa Hogan Hospital or to mortuaries. The stains found in Garner's car could have been from any of the bloodied victims.

The remains of young Chester Holestine, who had viewed the drive from Ava with his chum Charles Fisher as an adventure, could not be identified. Fisher's family claimed his badly burned body only after they recognized the two gold charms he had been awarded for his basketball and football prowess at Kirksville Teachers College.

Young Jack McFarland responded with disbelief to news of his mother's death. "Oh, no," he said, "it can't have happened again." He begged to be allowed to search for his mother. "I can find her. I know what she was wearing."

Despite Kitty McFarland's death, the McFarland Undertaking Company accepted nine identified bodies and twelve more that could not be assigned names. Paige and Dorothy Robertson, Kitty's assistants for many years, operated the facility during those trying days without the help of longtime employee Ben Jolly, who died in his bed in his room in the Ward Building. The Robertsons' already difficult task was complicated by the knowledge that the bodies of Dorothy Robertson's sisters, Billy Drago and Susan Drago Rogers, lay unidentified in one of the makeshift morgues.

As rescuers continued to comb the smoldering wreckage for bodies, people flooded into West Plains. Relatives and families of victims tearfully peered at the charred remains of victims, searching for familiar bits of clothing, shoes or jewelry—often the only means of identification allowing families to claim their loved ones for burial.

Items found in the ruins after the fire were removed to the office of Police Judge George Halstead. The hopes of many families, who prayed that their sons or daughters had not attended the dance that night, were dashed by the evidence of familiar keepsakes.

A number of tiny metal vanity cases were recovered from the ashes. With shattered mirrors, charred powder puffs and blackened cases, they were painful reminders of the young women who had cherished them. Among the items found were pins, lipsticks, keys and buckles, as well as a wide bracelet, a bit of a locket, a partial strand of beads and a lady's gold pencil. A metal mesh handbag still retained a dainty hanky, and the pocket in a piece of a man's coat held a neatly folded handkerchief. A layer of bricks had protected the fur-trimmed sleeve of a woman's coat. One watch was still running as it lay on a table in the judge's office. The rest of the watches recovered from the debris had been stopped at 11:04 or 11:05.

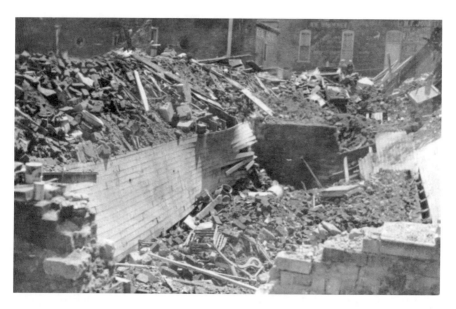

Previously unpublished photo, captioned "West Plains Holocaust," shows the total devastation caused by the explosion and fire. *Courtesy of Toney Aid.*

Saturday brought bitterly cold temperatures and a steady rain to West Plains. Throughout the day, workers continued to arrive from the countryside and nearby communities. The *Quill* described the scene in West Plains on Saturday as "a seething mass of automobiles and humanity."

Workers knew that no more survivors would be found, and they concentrated on sifting through the debris for traces of the dead. Men worked in relays to allow exhausted rescuers to rest physically and emotionally. Police officers stretched rope around the remains of the buildings to protect the area. As the gruesome search wound down, only charred carcasses and bits of burned limbs were recovered.

All of the patients admitted to both Christa Hogan and Cottage Hospitals required inoculations against tetanus, and the hospitals' supply of the serum was quickly exhausted. Dr. A.H. Thornburgh called his son Paul in Springfield, and Paul called his uncle Ernest Thornburgh of Sigler Wholesale Drug Company. The two men rushed to the company's storehouse, where they boxed a large number of units of the tetanus vaccine and raced the one hundred miles to West Plains, delivering their precious cargo by 7:00 a.m. the next morning.

The number of fatalities and the gruesome condition of many of the corpses overwhelmed local undertakers. Coroner T.R. Burns of the town of Willow Springs, twenty-three miles to the north, arrived to assist, as did H.H. Dyer of the Morse Undertaking Company and Leo Carr of the Carr Undertaking Company, both of Thayer. Norval Luna, undertaker from Mammoth Spring, Arkansas, also rushed to West Plains.

The *West Plains Journal* reported that "Sunday was a beautiful April day and thousands of visitors swarmed into the city and the hotels and restaurants were inadequate to cater to their food needs and some no doubt went away hungry." All roads into West Plains were clogged with people searching for loved ones or folks just curious to see the devastation. Highways as far north as Springfield and east to Poplar Bluff were jammed with traffic. One driver counted three hundred cars leaving West Plains at about 4:30 p.m. Sunday afternoon.

Big city newspaper reporters from St. Louis, Springfield, Kansas City and Memphis "swarmed like bees," according to one local newspaper. Paul B. Zimmerman, a special representative of the Associated Press, arrived by airplane to cover the story. A cameraman dispatched by Pathe News created a stir when he set up his motion picture camera and filmed the scene for a nationally distributed newsreel.

The explosion and fire made national news throughout the United States. On April 14, 1928, the *Post-Crescent* newspaper in Appleton, Wisconsin, ran

the story of the explosion on its front page under the headline, "36 Killed in Explosion in Missouri City, Dancehall Blast Changes Laughter of Merry-makers into Shrieks of Terror." Four days later, the same newspaper ran a photo of the ruins of the Ward Building under the headline "Blast Turns Dance Hall into Wreckage."

The *Sunday Messenger* newspaper of April 15, 1928, from Athens, Ohio, informed its readers of the explosion on page one under the heading "Explosion in Dance Hall Is Fatal to Many, Bodies of More than a Score Are Found in the Ruins Early Saturday."

The front-page headline of the April 14, 1928 *Lima (Ohio) News* reported: "32 Killed by Mystery Blast in Dance Hall—18 Missing Feared Buried in Wreckage Being Hunted by Rescuers." The following day, the *Lima Sunday News* featured another story: "Explosion Toll Mounts to 39."

The *St. Louis Globe-Democrat* sent personal sympathies to the community that read, in part:

> *The sympathy of the entire country goes out to the scores of homes in and near West Plains, Missouri, that are darkened by death as a result of an explosion that destroyed a hall in which a dance was being held by members of the younger set. It is seldom in a community of this character and size that a single blow lays the hand of death on so many families prominent in the life of the community.*

Coverage of the disaster was worldwide. In Australia, the *Canberra Times* newspaper carried a short account of the blast in its April 16, 1928 issue.

A month after the explosion, Jake Palmer, chief of the West Plains Fire Department, received a letter from Arthur R. Wyer, chief officer of the London, England fire brigade:

LONDON COUNTY COUNCIL
London Fire Brigade
Headquarters
Southwark Bridge Road, S.E. 1

16th April 1928
The Fire Officer
Fire Brigade
West Plains, Missouri
U.S.A.

Dear Sir:

I observe in the London Press this [microfilm unreadable] *on Friday, April 13 last, a fire and explosion took place in a garage in your town, with the result that 39 people were killed and 20 seriously injured, owing to the building above being used as a dance hall.*

I should be obliged if you would be so good as to favor me with the details of the occurrence, and any other particulars you consider might be of interest to the London Fire Brigade.

Thanking you in anticipation,

Yours faithfully,

Arthur R. Wyer
Chief Officer, L.F.B.

Thousands of expressions of sorrow and regret from governments, businesses, churches and individuals from all over the world poured into West Plains in the days following the explosion. Residents from a home for aged ministers in Marionville, Missouri, wrote: "We extend heartfelt sympathy to West Plains and those so sorely bereft. May God comfort hearts there today." Officials from the Frisco System wrote to Mayor Harlin: "Kindly convey to your people the sympathy of our officials and employees." Missouri governor Sam A. Baker sent a message from Jefferson City conveying his sympathy and offering the services of the state.

West Plains was in shock; it had barely begun to grieve.

SOURCES

Floyd Arnhart shared his account of the explosion in the *West Plains Weekly Quill* edition of April 19, 1928.

Seiberling, Landis, Fitzgerald and Toler gave their accounts in the *West Plains Gazette* of April 19, 1928.

W.H. Evans's account is from the *Douglas County Herald* of April 19, 1928, and the April 19, 1928 *Gazette*.

Details about the discovery of Mrs. Martin's body, Bus Langston's care at Cottage Hospital and Lester Blackiston's rescue of Fern McBride were

included in the story "The West Plains Explosion" in the *Gazette*, vol. 1, no. 1, spring and summer, 1978, pages 11–20, published by Russ and Michael Cochran.

Harry Zorn's account is taken from his testimony before the coroner's jury.

The help proffered by the Springfield Red Cross office was taken from the *Quill* of April 19, 1928.

The story about people viewing Bob Martin's demolished car came from an undated clipping from the *Springfield News*.

The account of Fern McBride's injuries and treatments came from the *Quill* of April 19, 1928, and April 26, 1928, and from a letter she wrote to the fall and winter issue of the *Gazette* in 1978, in response to the article about the explosion in the previous edition.

Jim McFarland of West Plains, grandson of Kitty McFarland, related to me the response of young Jack McFarland, Kitty's son, to the news of his mother's death, as told to him by Dail Allen.

R. Jones, G. Klain and H. Morton testified to their discovery of Wiser's body to the coroner's jury.

The Risners' search for their daughter's body was contained in their testimony before the coroner's jury.

The identification of Naomi Mullins's body via the locket given to her by her husband, Carl Mullins, came to this author from Carl's daughter, Carla Mullins Burns of Sterling, Virginia. Ms. Burns also supplied the information about Naomi Mullins's pregnancy.

The identification of Charles Fisher's body through the gold charms he had earned in college came from the *Gazette* of April 19, 1928, and the *Quill* of May 3, 1928.

The sympathies of the *St. Louis Globe-Democrat* were reported in the *Gazette* of April 26, 1928. Other sympathies appeared in the *Quill* of April 26, 1928, and the *West Plains Journal* of April 19, 1928.

The relocation of the Western Union office was detailed in the *Quill* of April 19, 1928.

Paul and Ernest Thornburgh's delivery of tetanus to the explosion victims and the names of the undertakers who assisted local mortuaries were taken from the *Quill* of April 19, 1928.

The work of Mr. and Mrs. Paige Robertson came from Robertson's testimony before the coroner's jury and the *Quill* of April 19, 1928.

Recovered items were described in the *Quill* of April 26, 1928.

The *Quill* of April 19, 1928, and the *Journal* of April 19, 1928, described the city on the weekend following the explosion.

The *Quill* of April 19, 1928, and the *Gazette* of the spring and summer of 1978 detailed the coverage of the tragedy by out-of-town reporters. Examples of the nationwide and worldwide coverage of the explosion were found through an Internet search of the subject.

REST IN PEACE

BURIALS AND MEMORIALS

Within days of the explosion, an agonizing procession of funerals brought the town of West Plains to its knees. Hardly a home in the tightly knit population was spared the loss of a family member or dear friend. Most businesses in the city, as well as in many neighboring communities, had not reopened since the Friday evening before the blast.

So many caskets were needed to bury the dead that employees of Ozark Casket Company in Houston, Missouri, worked for twenty-four straight hours on Sunday to produce the needed burial boxes. They were delivered to West Plains on two large trucks on Monday morning, April 16.

A service at the West Plains High School auditorium on Wednesday, April 18, memorialized senior Ruth Fisher, juniors Hugh Sams and Charles Merk and sophomore Marvin Hill, all of whom died in the explosion. A male quartet sang "Somewhere" and "Crossing the Bar" in memory of the four lost friends.

Kitty McFarland was buried on Tuesday, April 17. Hundreds of mourners filled her house and lawn. Reverend Roy Fairchild, rector of the All Saints Episcopal Church in West Plains, read the simple burial service. Flowers covered the casket and filled the home, and a quartet of singers provided music. She was interred at Oak Lawn Cemetery next to her husband. Their twelve-year-old son Jack was left an orphan.

Major Bob Mullins and his brother-in-law, Lev Reed, were eulogized in a double ceremony at the Christian Church that overflowed with mourners. The caskets were surrounded by dozens of floral arrangements, and Major Mullins's casket was draped with an American flag. A large contingent of friends from

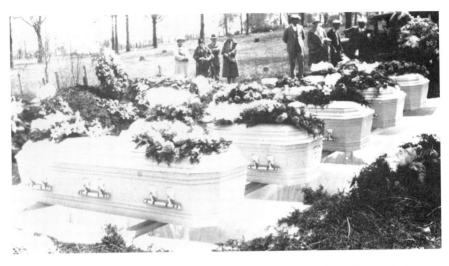

Twenty identical coffins containing the remains of unidentified victims of the explosion await burial at Oak Lawn Cemetery. *Courtesy of the* West Plains Gazette.

his military days attended the service, and members of the local National Guard Unit, Company D, attended his funeral in their dress uniforms.

The body of Mullins's wife, Eva, was disinterred from its original burial site to be laid to rest between her husband and brother at Oak Lawn Cemetery.

Blanche Martin returned the bodies of her father, mother and little sister to Memphis, Tennessee, where the family had once lived. On April 20, their lives were celebrated at the J.P. Hinton Funeral Home, and parents and daughter were buried at the Elmwood Cemetery.

At 10:00 a.m. on the morning of April 19, services were held in every church in West Plains, and tributes were accorded to the memory of the thirty-nine people who died in the explosion.

On that Thursday, John Bates, Olis "Chester" Holestine and Icie Risner were eulogized at the First Methodist Church by Reverend H.E. Ryan, the presiding elder of the West Plains District of the Methodist Church South. Bates's father, Reverend J.F.E. Bates, did not attend because he had accompanied his son's body to Bentonville, Arkansas, for burial in the family plot. The song "Fleeting Hour" was sung by a quartet of chums of Olis Holestine.

In addition to memorializing the unidentified dead of the disaster, services at the Presbyterian church recognized Esco and Mabel Riley, Newton Riley and Marvin Hill. Hill was a popular high school athlete in West Plains. Brothers Esco and Newt both worked at the Allen Grocery Store on Washington Avenue in West Plains, and they were known for their

courtesy and pleasant manner in dealing with customers. None of the men's bodies was identified.

Mabel Riley was just twenty-five years old at the time of her death, and she and Esco had been married four years. Her body was identified, but because her husband's body was not, family members chose to bury her with him and his brother in the common grave site at Oak Lawn Cemetery.

The altar at the Episcopal church was decked with bowers of flowers and glowing white candles at the memorial service for the unidentified dead. Special prayers were offered for Kitty McFarland, Billy Drago, Susan Rogers and Nellie James Murphy. A native of West Plains, Mrs. Murphy had attended a Chicago music school, where she became a trained soprano, before marrying Robert Murphy, a salesman from Springfield. They were visiting her parents at the time of their deaths.

The Christian Church paid tribute to Evelyn Conkin, sisters Billy Drago and Susan Rogers and Ruth Fisher. Fisher was a high school senior who was attending her first public dance the night of her death. She was a Girl Scout and Brownie troop leader, and both groups of children attended her service wearing their Scout uniforms.

High school senior and Scout leader Ruth Fisher was attending her first public dance. *Courtesy of the* West Plains Daily Quill.

While the individual services at area churches were heart-rending, the service for the unidentified dead at Oak Lawn Cemetery epitomized the compounded grief of the nineteen families whose loved ones could not be identified.

The morning of the funeral dawned cloudy with the threat of rain, but the sky cleared by mid-morning. Trees in the cemetery were budding, and spring flowers bloomed throughout the well-tended grounds.

A selection committee had chosen an oak-

shaded location on the south side of the cemetery for the grave. The area was named "God's Acre," a peaceful spot on a hill overlooking the large burial ground. Members of the Business and Professional Women's Club decorated the plot that measured thirty-three feet wide and sixty-six feet long with flowers and greenery, and floral sprays adorned twenty identical silver-gray caskets arranged in five rows. Within nineteen of them lay the remains of the unidentified victims of the blast. The twentieth casket belonged to Mabel Riley, whose family chose to bury her with the unidentified bodies of her husband and brother-in-law. Her casket was not marked, and with its closure, she became the last of the victims to lie in the common grave.

An area had been roped off to accommodate several hundred family members. Three of the people to be buried in the plot were members of Company D of the National Guard. Soldiers in full dress uniforms stood as sentinels in a circle around the plot. Mourners from West Plains, adjoining towns such as Thayer and Ava and points as distant as California viewed the ceremony. Local newspapers estimated that four thousand to seven thousand people attended the service.

Ministers from the Methodist Episcopal, Christian, All Saints Episcopal, Presbyterian, Baptist and St. Mary's Catholic Churches joined in a short ecumenical service to honor the dead and console their families. A large American flag flew at half-staff in the center of the plot, and the six ministers

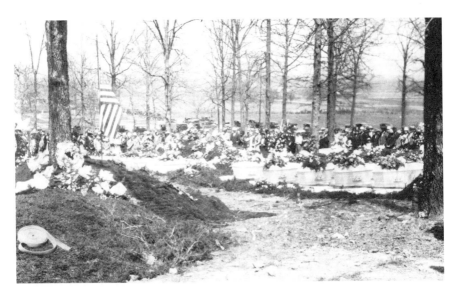

Thousands of mourners attended the funeral for the young people whose bodies were too badly burned to be identified. *Courtesy of the* West Plains Gazette.

gathered beneath it to conduct the mercifully brief service. After a reading of the names of the people to be buried at the grave site, the assemblage rose to recite the Lord's Prayer.

After the benediction, a solitary bugler blew taps, and another musician in a distant corner of the cemetery played the echoing refrain.

Several mothers of victims fainted, and doctors quietly administered to them. Mrs. Houston Conkin's only daughter, Evelyn, could not be identified after the explosion. Recovering from a serious illness, the distraught mother had left the hospital after hearing of her daughter's death. She sat dignified and dry-eyed throughout the ceremony, her face etched with sorrow. As she joined the final procession, she stopped at each casket to give it a loving touch. Before she completed the first row, she collapsed. Two young soldiers from Company D rushed to her aid. They gently lifted her into a chair and carried her around the plot from casket to casket so that she could lay her hands on each one and know that she had given her daughter a last caress.

After the procession of the family members, the rest of the mourners filed past the dead. Soldiers then lowered the caskets, five at a time, to their final resting places.

Clara Wiser, the thirty-nine-year-old wife of Joseph Marion "Babe" Wiser, was crushed by her husband's death. She would have to raise alone her two young sons: fourteen-year-old Paul Fred and five-year-old Roscoe. Another

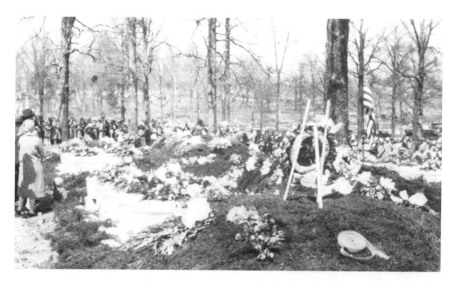

The West Plains Business and Professional Women's Club decorated the grave site with a profusion of flowers. *Courtesy of the* West Plains Gazette.

son, Joseph Herbert, had married Essie Johnson, and the two owned a farm near Alton, Missouri. Clara's only daughter, Clara Vivian, also lived in Alton with her husband, Irvine Barton. The entire family had gathered at Oak Lawn Cemetery on the afternoon of Sunday, April 15, to lay their beloved husband and father to rest.

Within an hour of the burial, officials arrived with shovels to exhume Wiser's body. Theories were forming about the cause of the explosion, and Joseph Wiser was at the center of most of them.

SOURCES

All details of the funerals of the thirty-nine victims of the explosion were culled from newspapers: the *West Plains Daily Quill*, the *West Plains Journal* and the *West Plains Gazette*.

INVESTIGATION

FACTS, RUMORS AND THE WRATH OF GOD

Officials wasted no time in appointing a coroner's jury to investigate the explosion at Bond Hall and the deaths of thirty-eight people and injuries to at least twenty-one others. (Elbert White would die within a week, bringing the final death total to thirty-nine.) Coroner T.R. Burns of Willow Springs, Missouri, empanelled six prominent citizens of West Plains on Saturday morning, April 14, while recovery workers were still combing through the smoking ruins.

Burns recruited Charles Richard Bohrer, Dr. S.G. Dreppard, H. Thurman Green, E.E. McSweeney, Clarence C. McCallon and Samuel J. Galloway to hear the evidence surrounding the explosion. The distinguished jury met in the offices of Police Judge George Halstead.

Charles Bohrer was appointed foreman of the group. A pharmacist and drugstore owner, he was part of a pioneer family that had produced several generations of doctors and druggists in West Plains. Dr. S.G. Dreppard was a veterinarian, H. Thurman Green owned a motor garage, E.E. McSweeney was the district manager for the Standard Oil Company and Clarence C. McCallon was proprietor of the Cash Clothing Company. The last member of the panel, Samuel J. Galloway, had been elected as the representative from Howell County to the state legislature in 1922.

Will H.D. Green, the forty-four-year-old prosecuting attorney for Howell County, attended West Plains schools before he studied law under his father, Judge H.D. Green. He was admitted to the bar in 1905. Green had headed up the "dry forces," sometimes referred to as the "Church of Dry Workers," in their successful campaign to drive the saloons from Howell County long

before prohibition became the law. An elder in the First Christian Church, Green was a longtime president of the Howell County Sunday School Association. As a lawyer, he steadfastly refused to defend any person charged with violating the liquor laws or with a crime against a woman.

Witnesses were called before the panel on Saturday, Sunday, Monday, Tuesday and Wednesday (April 14 through April 18), sometimes testifying far into the night. Public pressure demanded that the coroner's jury find the cause of the explosion and fire. If someone intentionally detonated the blast, the town wanted to know the perpetrator's name.

The jury's working hypothesis was that gasoline stored in the Wiser Motor Company below Bond Hall exploded, causing the holocaust. Because the science of forensic pathology was unknown in 1928, members of the coroner's jury could consider only the testimony of contemporary experts on explosives and then call on their own common sense and experience to make a determination. The responsibility of identifying a specific culpable person or persons weighed heavily on them.

In a letter dated April 20, 1928, addressed to Mayor Harlin and the city commissioners, W.J. Orr of Springfield, an attorney for the Frisco Railroad who had investigated explosions for the railroad, offered information about the power of gasoline-fueled blasts. Orr wrote that only through "sad experience" had he gained knowledge about such explosions and that many of the safeguards thought to be sufficient in the storage and handling of gasoline were actually inadequate and sometimes dangerous. Orr noted that, although gasoline in liquid form is less dangerous than the vaporous form, "there is sufficient energy stored in 1 gallon of gasoline [to] lift the Woolworth Building in New York City about six inches off its foundation." A mixture of gasoline vapors and air "will explode if there is not more than six percent of gasoline vapors in the mixture," he wrote. It will not explode if the percentage of gasoline is less than 1.5 percent of the mixture. "When the percentage is between these two extremes, that is, when the mixture is not too rich or too lean, the mixture will explode."

An article printed in the *Springfield Daily Leader* and reprinted in the *West Plains Weekly Quill* on April 26, 1928, quoted engineer and explosives expert Will F. Plummer. According to Plummer, "If there is a grain of compensation to be found in the West Plains disaster it may be that people will learn something of the dangerous explosive power of gasoline." He described a situation in which gasoline fumes could have accumulated in the basement of the Ward Building, causing the explosion. However, the Ward Building had no basement. Plummer offered the following evaluation: "To

wreck so completely such a building would take, I should say, 200 pounds of 60 per cent dynamite, more than could be handled secretly, or more nitroglycerin than was ever assembled. On construction work we are not afraid of dynamite. Its power is greatly overrated, but nobody knows the shattering force of gasoline."

The members of the jury knew that gasoline was present in Wiser's garage. Ray Fisher of the Standard Oil Company testified that he had leased a fifty-gallon gasoline pump tank to Wiser on the Wednesday prior to the explosion. The tank was on wheels and could be moved around the building. Leonard Fite, Wiser's salesman, estimated that the tank held forty gallons of gasoline at the time of the explosion. He testified that the gasoline was used for employees' personal use and to fuel cars being tested by prospective buyers. He believed that the tanks on all the cars parked in the garage were empty.

Small amounts of gasoline purchased by Wiser on the day of the explosion raised questions about his involvement in the blast. Raymond Tiner worked for the Standard Oil station in West Plains. On Friday morning at about 8:00 a.m., Tiner sold five gallons of gasoline to Wiser. Only after the explosion did he think that the sale was significant. Carter Johnson, a salesman who worked at Carac Davidson's garage, testified that he loaned a gasoline storage can to Wiser on Friday just after noon. He said that Wiser often borrowed the can. Sanford Palmer, another employee of the Standard Oil station, testified to selling Wiser thirteen gallons of gasoline at about 12:30 p.m. on Friday. He pumped eight gallons into the tank of the Chevrolet coach that Wiser was driving and five gallons into a gasoline storage can, presumably the one borrowed from Davidson's garage.

Thomas McCord, chief engineer for Texas Company in Oklahoma, worked as "an inspector of natural gas." After examining the ruins on East Main Street, he testified before the coroner's jury. He told the jurors that he had witnessed four large gasoline explosions and four small ones. He had also observed two nitroglycerin explosions. McCord stated that during an inspection of the explosion site, he found the fifty-gallon tank of gasoline in Wiser's garage "intact." He concluded that the detonation of the tank was not the cause of the blast. He testified that sixty gallons of gasoline, a generous estimate of the amount in Wiser's garage, was insufficient to produce an explosion the size of the one that demolished the Ward Building. Only if all of the gasoline had evaporated into a confined location and then "had some pressure on it" would it have exploded. "From appearances," he said, "I would think nitroglycerin or some explosives had caused it."

Mr. Ridgeway testified that he operated Ridgeway Dry Cleaners on Walnut Street in a building situated between the back (south side) of the Adams Building and the north side of the Arcade Hotel. Ridgeway's building sustained little damage. Only "the door and windows [were] blown out and the glass broken." Ridgeway said that Fluid Stanoline was the primary medium used to clean clothing but that most dry cleaners also kept gasoline, chloroform, ether, acetone carbon and alcohol in small quantities. Although he had heard of gasoline explosions at dry cleaning establishments, none was as large as the one at Bond Hall.

When asked if he thought vapors from the gasoline in Wiser's garage could have caused the explosion, he said, "Gasoline within itself is not explosive, but the vapor must be mixed with air and be heated enough to form some pressure before it can explode." He noted that salesman Leonard Fite and mechanic Jim Jewell had both testified that the stove in the garage was inoperable. Therefore, based on the amount of gasoline believed to be present in the garage and the lack of a heat source, Ridgeway did not believe that the blast was due to a gasoline explosion.

The jury could not determine if gasoline vapors had been present in the Ward Building prior to the explosion. Mr. Pool in his rooms at the Arcade Hotel and Beverly and Hattie Owen in the Riley Building all reported smelling gasoline before the blast. However, Mrs. Hawkins in the Adams Building, Warren Blakley inside his creamery in the Riley Building and Mo Ashley arriving at the dance smelled nothing out of the ordinary.

Without another suspect, the coroner's jury focused on Joseph Wiser, and within an hour of the burial of his remains on Sunday, the jury had ordered Wiser's body exhumed for a formal autopsy. The jury was troubled by his injuries and burns because they appeared inconsistent with those of other victims. Richard M. Jones, Grover Klain and Haydon Morton, three of the four men who discovered Wiser's body after the explosion, testified about its location and described its condition.

George Stapp, undertaker at the Davis-Ross Undertaking Company, where Wiser had been taken, testified about the condition of the body, and he stated that Wiser's clothes were not torn or burned. "His hair seemed to be singed and full of dust and gravel," he told the jury. "His face had a few small scars on it, and the burn on his face looked like acid burns, fiery red in color."

Wiser's lips were discolored black, which Stapp stated was normal for a deceased person. During his first examination, he noticed the fiery red color of Wiser's skin, and Stapp stated that he had not washed or rubbed the face in any way to cause this coloration. Only on the man's forehead were any

burns evident, and Stapp believed that they were consistent with "powder" burns because they were spotted with a bluish-black color, not a solid burn. Stapp admitted that he had never seen burns like them in the past. Stapp further testified that Mr. Dryer, mortician from Thayer, removed Wiser's clothing, and Stapp and Jim Bridges collected Wiser's watch, a few papers that were in his clothing and thirty-one dollars in cash. They noted that they found no matches in his pockets.

Physicians Lee M. Toney and H. Thornburgh testified about their findings from the autopsy they performed on Wiser's body on the Sunday following the blast.

Dr. Toney stated that he found "penetrating wounds on [the] left side of the chin in front about an inch deep, [and] found contusion [to the] right temple, [a] region which upon opening up showed a fracture probably [an] inch and a half long, [and a] half inch wide." He testified to "considerable discoloration" to the body but assumed that it was "due to the epidermis being rubbed off by the undertaker." Wiser's hands were burned to about an inch above the wrists, and he sustained a compound fracture of the right leg midway between the ankle and the knee. Since the blood in Wiser's temple wound was clotted, the doctor believed that the injury could only have been sustained while the man was alive. However, Dr. Toney believed a "lineal fracture of the skull to the right of the occipital protuberance" could have occurred after Wiser's death, perhaps from flying debris or falling timbers, although it could have occurred prior to the explosion.

Dr. Thornburgh testified to "dissecting the scalp," during which he

> *found [a] depressed fracture of the skull in the right temple region about one inch and half long extending from the interior of the right temple downward and forward to the outer angle of the right eye. The temple muscle was out underneath and full of blood clots. The skin over the fracture was not broken. Also, [he had] a fracture of the skull at the upper occipital bone, I judge two inches long. The right side of the face was discolored dark red, and this indicated that he had been burned by acid rather than fire. The color of the burns being much different from that on his hands. The eyebrows and lashes were entirely burned away. The right arm was bruised and contused. Midway between [the] knee and ankle, both bones [were] broken. Also, [I found] a wound on the chin about one inch and a half to the left of the median line.*

A deep puncture wound on the chin extended to the bone.

Dr. Thornburgh testified that he believed that if Wiser had been inside the building and blown through the brick wall, he would have exhibited more broken bones. However, he agreed with a questioner that Wiser could conceivably have been blown out through an open door at the rear of the garage. The burns, he said, could be explained if Wiser had gasoline on his hands at the time of the explosion. In comparing the burns of Wiser to the burns of Ford dealer Robert Martin, the doctor said that Martin's were much more severe. "The burns on the other person [Martin] were alike as to color and its effect on the skin while the burn on Wiser's face was a perfectly smooth burn and left the surface of the outer layer of skin blistered red, bright red, and not a dark or blue color and not deeper than the outer layer." Wiser's hands, however, "both had the same marks as those who had been burned by gasoline flames."

"Couldn't these burns on his hands [have] been made by him having gasoline on his hands, and when the explosion went off, burned his hands in that manner?" asked a questioner. Dr. Thornburgh answered in the affirmative.

Thornburgh told the jurors that he knew that nitroglycerin was made from ingredients that could be purchased at any drugstore and mixed by anyone who understood explosives. Although he had previously seen carbolic acid injuries and other types of acid burns, he had not seen any burns like the ones on Wiser's face. He did not care to give an opinion about what might have caused the burns.

When asked for his opinion about how Wiser's hands could have been blistered to the wrists but his face marked only with "very peculiar red spots," explosives expert Thomas McCord admitted that he had never seen burns like that, but he theorized that Wiser's "hands [could have been] in gasoline [when it] ignited and burned his hands."

Initially, Wiser's burns troubled the jurors, but after visiting one of the survivors in the hospital, they believed that they understood the differing patterns of injuries. On April 26, 1928, the *West Plains Weekly Quill* reported that the jury had visited Christa Hogan Hospital to view the face of Lewis Achuff (also spelled "Acuff"), who had been dancing in the hall at the time of the explosion. According to the *Quill*, his face was "burned in identically the same manner, indicating that he came in contact with a sudden flash of flame or heat before he escaped." The panel concluded that Wiser's burns were "flash burns" that resulted from one quick flash of flame or heat instead of the steady heat that had seared so many of the other victims.

One aspect of Dr. Toney's testimony caught the attention of the jury. Toney's belief that Wiser could have sustained the skull fracture prior to the explosion raised the possibility that he might have been attacked by "yeggmen," a term

of the time for burglars or robbers. The panel considered that one or more of the men seen inside the garage with Wiser that night could have attacked the garage owner, who was rumored to have made substantial profits from his telephone business. The jurors theorized that such attackers might have set a fire to cover their crime and that the fire ignited the explosion.

Several witnesses placed Wiser in his garage on that evening, including Arnold Merk, who testified to seeing two men inside Wiser's garage at about 10:30 p.m. Night constable Els Seiberling also reported seeing a man in the vicinity of Wiser's garage at about 11:00 p.m. The man got into a Ford roadster and drove west on East Main Street. "It seemed he was in a hurry," Seiberling said.

Seiberling also recalled seeing some people from the carnival that was performing in West Plains. Early Friday evening, Seiberling recognized the carnival's electrician standing in front of the Baltimore Hotel, located two blocks north of the square at the corner of Washington Avenue and Broadway. Inside the hotel's café, he saw a female performer from the circus. At about 11:00 p.m., just prior to the explosion, he saw the carnival people on the west side of the square driving a big car loaded with suitcases.

Alace Davis, who worked at the Broadway Hotel, described the carnival people—Mr. Dinsdale, Mr. Carlin and Miss Reynolds—as tough-looking people "who could have used better language." She said that they stayed at the hotel from April 5 to April 15. After the explosion, Mr. Carlin asked her if an officer had been around inquiring about them because "they had to be accused." His comment reflected his understanding of the unsavory reputations sometimes attached to carnival employees. No testimony from the carnival workers appears in the coroner's jury transcript.

John Renfrow testified that at about 10:15 p.m. he had just left the Methodist church and was driving along East Main Street past Wiser's garage when he saw Wiser and three men inside the garage. Wiser was leaning against a vehicle, and the other men were standing just inside the front door. Renfrow called out a greeting to Wiser, who smiled and raised his hand in response. Renfrow thought at the time that the men, who were wearing suits, might be from General Motors, but he was not acquainted with any of the company's representatives.

One telling question set the stage for another scenario to be examined during the investigation. One of the questioners asked Renfrow, "Either of these men resemble Bob Mullins?"

"Well, not in height and too fleshy for Bob," said Renfrow. "All rather heavy men—rather tall, large men."

The question about a man resembling Bob Mullins apparently arose from the statement that Mrs. Pleas "Dutch" James gave to the *West Plains Daily Quill*. She said that she and her husband had been awakened by the blast and had run to their door to determine the source of the sound. She saw a man hurrying past her house half a block from Bond Hall. She thought the man was Bob Mullins, and she called out to him asking about the sound of an explosion and wondering if anyone was hurt.

"Yes, I guess they were. I heard a lot of them screaming," said the man, who continued on his way.

Jury members wondered about a man walking away from the disaster while everyone else was running toward it. That man could not have been Bob Mullins, though; he was already dead in the ruins of Bond Hall.

George Stapp, the undertaker from Davis-Ross Undertaking Company who testified about the condition of Wiser's body, told the *Quill* that as he ran toward the scene immediately after the explosion, he saw a man running away from the dance carrying two one-gallon bottles. The editors of the newspaper, in an article dated April 26, suggested that the two men seen with Wiser inside his garage just before the explosion might have been the men James and Stapp saw leaving the scene.

A man identified only as Mr. Stewart testified that he was standing on Walnut Street at the time of the explosion when he saw two men running south away from Bond Hall.

"I dodged across the walk," he said. "One went past me and almost hit me." In an odd addendum, Stewart said that the men he saw "didn't have on overalls." When Roy Hill testified to seeing a man running north on East Cleveland Street, jurors asked him if the man was wearing overalls, and Hill said he didn't recall. Nothing in the recorded testimony or in newspaper items indicated why the jurors inquired about a man wearing overalls.

Frank Cook testified that he arrived at Bond Hall at about 11:00 p.m. He stood in the door watching the dancers for a few minutes and decided not to stay. Coming down the stairway from the hall, he noticed two young men sitting on the bottom step. When he returned to his car, he saw Els Seiberling on the sidewalk. He turned his car around and drove at about twenty miles per hour down East Main Street toward his home. Cook could have been the man Seiberling saw leaving the area just before the explosion.

After he heard the explosion, Cook returned to Bond Hall. As he was approaching the 100 Block of East Main, he noticed the two men he had seen sitting on the stairway running away from the fire.

The coroner's jury considered the possibility that Wiser had caused the explosion as an act of suicide because of financial problems. However, testimony from bank cashier Howard Kellett seemed to discredit that theory, although he confirmed the rumor that General Motors had threatened to take the agency away from Wiser. The banker assessed Wiser's situation as "better than it was three months ago." Kellett also stated that Wiser had seemed in good spirits when he saw him in the bank Friday afternoon.

Clara Wiser told the *Quill* that her husband had been worried about his finances some weeks before the explosion, but he told her that their financial situation was improving. She said he was not depressed and certainly not suicidal. Salesman Leonard Fite testified that Wiser was his usual cheerful self that Friday, "cutting up like he always did." Only Warren Blakley thought Wiser seemed distracted, "acting funny," when he stopped in the cream shop at about 4:00 p.m. on Friday afternoon.

The question of Wiser causing the explosion to collect the insurance money on the garage came before the jury. Insurance agent George Halstead testified that he carried insurance on Wiser's business that covered fire and theft for the actual value of the vehicles. The policy provided no insurance on parts stored in the garage, even though he and Howard Kellett had urged Wiser to take out such coverage. Halstead stated that Wiser was supposed to make a report of the vehicles he had in the garage every month; however, he was two months behind in his reporting. The inference was that a man planning to burn down his business for the insurance money would make sure his policies were up-to-date.

The coroner's jury also considered enemies Wiser might have made in the year he lived in West Plains.

James Bell, who operated the café located east of Wiser's garage in the Adams Building, testified about a conversation he had with Wiser just days before the explosion:

> He had some trouble with a car that he had sold to Orr [a salesman employed by Wiser]. *He tried to sell the car to me for $200. He said he sold this car to Orr for $500, I believe was the price. Anyway, I said why didn't he keep it; why are you trying to sell it to me? He said, "Well, I'll tell you." He went in and got the note and showed me he had a $500 note. I said, "You took* [the car] *away from Orr. You might take it away from me."*

While the transcript of Bell's testimony is somewhat jumbled at this point, Bell told the jury that Wiser said that someone had come into his garage

to buy a vehicle. Salesman Orr told the customer that if he would buy the vehicle—apparently the disputed vehicle—Orr could get his money back from Wiser. Orr then threatened, "If you don't [buy it], I will put something in to ruin it."

"When Wiser came back, the boys told him [what Orr had said], and he hunted Orr up, and he denied it, and he kept on until he owned [up]. And he [Wiser] fired him," testified Bell. "Orr went off and in a few days General Motors people were down and were talking about it to Orr, and Orr was talking about it, and he said he would never pay this note."

According to Bell, Wiser had both the car and the note. "Wiser owed him money, and Orr couldn't get it," said Bell. "Wiser told me Orr said he wouldn't pay for it if it run for him ten years and said, 'See if I don't get it.'"

It is unclear from the transcript whether Orr or Wiser made the comment, "See if I don't get it."

The coroner's jury apparently did not question salesman Orr about his dispute with Wiser because no testimony from him appears in the copy of the report. (A man by the name of Herbert Orr testified before the jurors. However, that Orr was a desk clerk at the Arcade Hotel, and he testified to his actions after hearing the explosion.) Why the jurors failed to interview a man who had a public argument with Wiser and who had threatened to damage a vehicle that was stored in Wiser's garage that Friday evening is unknown.

Orr wasn't the only person with a potential motive toward Wiser. A number of people testified about a strained relationship between Wiser and Charles R. Lashley Jr., who like Wiser was better known by his nickname of "Babe."

The *Quill* reported on December 24, 1925, that Lashley, an automobile salesman, had been arrested on two charges of burglarizing the local Ford agency. Lashley admitted that he had a key to the front door of the Ford garage and that he entered the establishment and burglarized it. The newspaper article gives no indication if the Ford dealership burglarized by Lashley was Bob Martin's dealership.

Lashley pled guilty to two counts of burglary and two counts of larceny and was sentenced to eight years in the state penitentiary. He must have been a model prisoner, because in February 1926 he was paroled. He returned to West Plains and went to work for J.M. Wiser as an automobile salesman.

In February 1928, Lashley was returned to prison for violating his parole. At the parole violation hearing, J.M. Wiser testified that Lashley had knowingly and fraudulently sold a mortgaged automobile. Others accused Lashley of operating a fake auto raffle and with writing worthless checks. At

the time of the sentencing for the parole violations, Lashley was just twenty-two years old with a young wife and baby.

Members of the coroner's jury asked several witnesses if they had seen any of Lashley's family or friends in the vicinity of Wiser's garage the night of the explosion. Leonard Fite testified that he had started work for Wiser three days after Lashley left Wiser's employ. When asked if he had seen Lashley's brother around the garage, Fite responded, "I don't know him at all." He further stated, "I don't think there was any really hard feelings with Mr. Wiser [but] I think Lashley felt hard." When asked if he thought that Lashley was angry enough to try to get back at Wiser, Fite said, "I don't know."

When Wiser ordered the fifty-gallon storage tank placed in his garage, he made a comment about Lashley to Ray Fisher, employee of Standard Oil Company. Fisher testified to the coroner's jury that Wiser told him that he had removed a similar storage tank because Lashley was stealing gasoline from it.

A.W. Gray operated an automobile sales and repair shop in West Plains. He told the jurors that he and Wiser had been partners in a garage soon after Wiser came to town. However, Gray severed their business dealings after Wiser hired Lashley.

"I said I don't want anything to do with a business Babe Lashley was connected with," testified Gray.

Gray testified to a conversation he had with Wiser about a month before the explosion. He said Wiser told him, "If I had listened to you, I would have been better off. I have been deceived [by] Lashley.'"

The most scandalous aspect of the investigation centered on Wiser's relationship with Ida Lee, the woman who told Wiser that her brother was sending her money to buy a car. Realtor and insurance man Eugene Oaks testified that he believed Lee, his secretary, had misled Wiser about her ability to buy a car.

Dutch James testified that Wiser asked him if he knew anything about Lee's financial condition, because he had been taking her for demonstration drives in an Oakland coupe that he had for sale. James told Wiser that he doubted that she was able to buy such a high-priced car. In response to a juror's question about other women in Wiser's life, James said, "That is the only woman I ever knew of him being with besides his wife and daughter."

Beverly Owens testified that he saw Wiser in a car with a woman Friday afternoon at about 4:30 p.m., but he assumed that she was Mrs. Wiser. He didn't know that Mrs. Wiser was home tending her sick child.

Mrs. Roy Crain offered a scathing denunciation of Ida Lee to the jury. She testified that Lee had boarded at her house on Missouri Avenue in West Plains for four or five weeks. She said that Lee paid her five dollars for a month's rent out of her nearly twenty-five-dollar monthly income. Lee had bragged of dating seven married men, and Crain disapproved of her boarder's behavior. As for Joseph Wiser, Crain said that Lee had borrowed her telephone to call Wiser to ask that he take her driving, but Crain thought that Wiser's attitude toward Lee was just business. She suggested that Lee's interest in buying a car "was a way that she had of trying to lead him [Wiser] out."

Crain seemed to give Wiser a ringing endorsement with her final comment to the jurors: "I think Wiser was a pretty good man, or he would have done more than he did. And Mrs. Lee's daughter-in-law thought so, too. We both thought he would be all right if the woman would leave him alone."

After Wiser's body was found in the field behind his garage, Lee convinced A.W. Gray to drive her out to the Wiser home so she could speak to Mrs. Wiser. A week after the explosion, Lee resigned her job at Eugene Oaks's office and left town.

Even the Wiser family's attendance at the Pentecostal church came into question. The denomination was squarely against dancing, and the jurors believed that Wiser might have caused the explosion to punish the dancers in Bond Hall. Leonard Fite described Wiser as "a very religious man," but he denied hearing Wiser speak against the Friday night dances. Mrs. Wiser testified that her husband had never expressed any negative comments about the dances at Bond Hall.

Dutch James said, "[Wiser] would always talk about the Bible and say, 'I do wish people would do right.'" He stated that he never heard Wiser speak against dancing.

Although no one could recall the garage owner denouncing the dancers, other West Plains residents had vociferously condemned them.

John Henry Mahan testified about a confrontation between a local judge and Pat Malone, an itinerant Pentecostal preacher. Ministers had traditionally been allowed to preach in the courthouse for a fee of $2.50. However, Judge Colvin refused to allow Malone into the building, and an angry dispute ensued. Eventually, Malone moved to the Pentecostal hall to speak, and Mahan heard him harshly denounce dancing and dancers. He described Malone as a religious fanatic.

Leslie Edward Hines told the jury that he had met Pat Malone five years earlier in Wisconsin. He described himself and Malone as members of the

Christian Church, and both were strongly opposed to dancing. Hines said that Malone was angry at the city of West Plains for prohibiting him from speaking in the courthouse. Reference was made to a threat by Malone to send his "10,000" to gain revenge. Hines insisted that he was unfamiliar with the allegedly secret order of religious followers of Malone.

One juror asked, "Would you have the opinion that Mr. Malone or this 10,000 would be bitter enough toward West Plains to have committed such an act?"

Hines said he did not believe Malone would but that he did not know about the order.

Roy Jackson testified that a fellow who worked at a West Plains restaurant overheard a customer threaten the owner of the Riley Building.

"Well, I'm going to wreck this place," the customer said. "I don't believe they would condemn it."

After the explosion, the restaurant employee wondered if the man had carried out his threat by destroying the Ward Building.

Mike Fitzgerald reported that after the fire had been extinguished, he was standing in the alley across East Main Street from the explosion. When he bemoaned the terrible loss of life, a stranger commented to him that the victims should not have been dancing: "They could have been in a better place."

"I didn't know him," said Fitzgerald. "I wish I had questioned him more."

Immediately after the explosion, the *West Plains Daily Quill* editors, Charles Bohrer (foreman of the coroner's jury) and a number of patients in Christa Hogan Hospital received what the *Quill* described in its April 26, 1928 issue as "fanatical religious letters and literature, which are sickening and disgusting." The cover of a booklet entitled *The Last Days* displayed a graphic picture in vivid color showing people dying by fire. The sixty-two-page publication had been printed in Brooklyn, New York, but its envelope bore a postmark from St. Joseph, Missouri. The *Quill* editors concluded, "All of these are weird and foolish and evidently written by persons of ignorance and illiteracy."

The *Quill* printed the text of one letter:

> *Have just read of your narrow escape from death in the dance hall. How sad to see so many plunged into eternity and going as they did from a dance evidently they were not prepared to meet their God. You surely ought to be thankful to God for sparing you the same reward. This should be a solemn warning. For ye know neither the day nor the hour, for in a time when ye*

think not the son of man cometh. Just as was the case of those who lost their lives so suddenly. Please heed the warning you have just had and seek salvation [the Bible] *for your sins.*

The letter was signed by J.H. Wilson Jr.

Local officials believed that the material was sent by "religious fanatics who were inspired by newspaper accounts of the disaster here to take advantage of what they probably think is an opportunity to sell a lot of their religious literature." On April 26, the editor of the *Gazette* editorialized about the literature that called the explosion God's punishment for dancing: "We know that this is not true because He is not that kind of a God."

On Monday, April 23, the coroner's jury met in final session to provide its verdict to Coroner T.R. Burns. The jurors could not determine the cause of the explosion and fire. They requested that Prosecuting Attorney Green continue to investigate the case in the hope of finding new clues.

T.R. Burns sent the following letter to the Howell County Court:

> *To the Honorable County Court,*
> *Of Howell County, Missouri*
>
> *Gentlemen:*
> *As Coroner of Howell County, myself and the jury have investigated the cause of the explosion, fire and deaths in West Plains the night of Friday, April 13, 1928, with the results you have no doubt seen as set forth in the jury's verdict as appears in the press and the official copy filed with your body.*
> *As Coroner, I wish to recommend to your honorable body that you give complete authority to Prosecuting Attorney, H.D. Green, to go further with this case and determine, if humanly possible to do so, the cause of this terrible calamity.*
>
> *Very Respectfully Submitted,*
>
> *T.R. BURNS*
> *Coroner*

The following is the full report of the coroner's jury as printed in the April 26, 1928 *West Plains Weekly Quill*:

We, the jurors impaneled and sworn on the 14th day of April, 1928, at the Township of Howell, in the County of Howell, State of Missouri, by T.R. Burns, Coroner of Howell County, Missouri, to diligently inquire and true presentment make how and by whom:

Robert G. Martin, Mrs. Robert G. Martin, Kitty McFarland, Mrs. Carl Mullins, Paul Evans, Jr., Charles Fisher, Major Bob Mullins, J.W. [sic] Wiser, John Bates, Charles Merk, Julian C. Jeffrey, Carl Jackson, Soula Gaines (Dimple) Martin, Lev Reed, Hazel Slusser, Ben Jolly, Clinton Clemmons, Mary Adair, Frances Drago, Mrs. Wallace Rogers, Robert Murphy, Mrs. Robert Murphy, Miss Ruth Fisher, Marvin Hill, Evelyn Conkin, Esco Riley, Mrs. Esco Riley, Icie Risener, Boyd Garner, Carson McClelland, Chester Holestine, Beatrice Barker, Juanita Laws, Miss Ruby Hodkinson, Newt Riley, James Loven, Hugh Sams, whose bodies were found in the wreckage, on East Main street in block 1, Howe's addition in the city of West Plains, Howell County, Mo., on the 14th day and 15th day of April, 1928, came to their death between the hours of 11 and 11:30 p.m., April 13, 1928. Having viewed the bodies and heard the evidence do find that the aforesaid persons and each and everyone of them came to their death simultaneously, by reason of a fire, explosion and the collapse of the walls of said buildings and general conflagration, and we do further find that the fire and explosion originated in the Wiser Motor Co., garage and occurred while J.W. Wiser was in or around the Wiser Motor Co., which was located in said block immediately below the hall known as Bond hall which was being used for the purpose of a dance, and was available and used for various gatherings of civic and social nature and the cause of said fire and explosion is unknown to the jury.

Given under our hands this 23rd day of April, 1928.

Charles Bohrer, Foreman
S.J. Galloway
Dr. S.G. Dreppard
H.T. Green
C.C. McCallon
E.E. McSweeney
Attest: T.R. BURNS, Coroner

The copy of the transcript of the coroner's jury report provided to the author by Dorotha Reavis had a page affixed to the front with a very different

report. With its ungrammatical, discordant language, the report bears little resemblance to the official report produced by the educated gentlemen who were members of the jury. The report reads as follows:

REPORT OF INQUEST INTO 1928 EXPLOSION

The West Plains explosion happened the night of April 13, 1928 at 11:10 p.m. The building blowed up consisted of a cream station and a store owned by Mr. Owens, a plumbing shop owned by Mr. Laird, other rooms both down and upstairs, some with roomers and the center room down the garage with Mr. Wiser. The explosion occurred in the Wiser garage. Directly over the garage part there was a dance hall with a dance in progress. This hall was blown up through the roof and 39 people lost their lives. A few were in other parts of the building, but most were in the dance hall. The explosion was great enough to be heard as far as Thayer, twenty-eight miles away. It was a deep sound, felt as much as heard.

Most of the bodies were burned very badly.

The body of Wiser was found in a lot back of the building lying on and under part of the debris. His legs were broken, his hands burned brown and the body showed the effect of intense heat but one side of his face appeared a bright red, almost crimson. This peculiar red was not found on the other bodies or on other parts of Wiser. His chin had a hole in it about the size of a .25 cal. bullet.

The coroner's jury was called and turned in a verdict of cause unknown. Reports were circulated that Wiser was connected with a woman. Also that he had blowed it up to collect insurance as his financial condition was very bad. Also that it was done by a fanatical preacher that had had trouble in West Plains.

The jury was not able to do any good with these theories and after a few days, the opinion of the public began to change to the idea that it was an accident with gasoline.

Reports were heard of rewards, but none seems to have been actually offered. It was also reported that private detectives were hired by the prosecuting attorney, but this was very unlikely. There was a lot of talk the first week about finding the guilty parties but no more efforts were made. Several leads were brought out in the coroner's investigation that were not followed.

The following report what these leads have lead to is all evidence that can be completely proven. It is made without names with the key for reasons

best known to the investigators. The investigators have all been private. All expenses have been borne by the investigators.

The report bears no signature or date. Who penned it or when and why it was attached to Ms. Reavis's copy of the transcript of the coroner's jury are unknown. The second report states that Prosecuting Attorney Green did not continue the search for clues; therefore, the families of the victims may have employed private investigators to answer their questions about the explosion. A longtime resident of Ava told the author that Olis Holestine's family employed an investigator but that no report prepared for the Holestine family was found.

The author of the mystery report refers to the wound on Wiser's chin as being consistent with a bullet hole. Neither of the physicians testifying before the coroner's jury described the injury as a gunshot wound. Virginia Graham and Barbara Morgan of Lebanon, Illinois, granddaughters of J.M. Wiser, told the author that their grandmother had always maintained that her husband had been shot the night of the explosion and was himself a victim and not the perpetrator of the blast.

Reavis obtained her copy of the transcript of the coroner's jury investigation from Helen Frater, a member of the Robertson and Drago families. Charles Drago, nephew of Billy Drago and Susan Drago Rogers, who died in the explosion, had no knowledge of an investigation commissioned by his family. The son of Robert Tillman Drago, youngest brother to Billy and Susan, Charles told the author that the tragedy was seldom discussed by family members. Drago mused that a tragedy such as the Bond Hall explosion would have provided opportunities for any number of unscrupulous people to have offered distraught families the hope of explaining the explosion that claimed their loved ones' lives. Charles's sister, Roberta Lynne Drago Silva, now deceased, maintained an extensive genealogy of the family. However, no report of an investigation into the explosion was uncovered during her search into the Drago family history.

The official investigation left many unanswered questions. If law enforcement acted on the leads uncovered by the jury, no publicity was ever dedicated to their investigation. Apparently, none of the men seen with Wiser in his garage prior to the explosion ever came forward to explain their late-night visit, and only one of the men seen leaving the area of the explosion approached officials to explain his presence. Whether anyone ever located or interviewed the carnival people or the preacher Pat Malone and his ten thousand followers is unknown. We are left to wonder if Babe

Lashley's family and friends or former salesman Orr had alibis for that night. Further, one wonders if the disputed vehicle was still in the garage at the time of the explosion, or had it been reclaimed by Orr.

Although the second report states that no reward was offered by Will H.D. Green, the following item appeared in the April 26, 1928 issue of the *Quill*:

REWARD

While the Investigation of Coroner's Jury and County Officials has failed to definitely solve the cause of the explosion as to whether it was accident or otherwise, I am at this time authorized to announce that by authority of the Howell County Court and the City of West Plains a reward of $1,000.00 will be paid for information leading to the arrest and conviction of any person or persons willfully guilty of causing the fire and explosion.

H.D. Green, JR.
Prosecuting Atty.
West Plains, Mo.

Within a month of the explosion, stories about the investigation into the cause of the blast disappeared from the pages of West Plains newspapers, while accounts of the settlement of the various victims' estates became the subject of public consideration. The search for answers by Will H.D. Green, the Howell County sheriff and the West Plains police force may have continued after the coroner's jury issued its report, but no additional reports appeared in newspapers, and no arrests were ever made.

Some explanation for what today seems a bewildering lack of follow-up to the initial investigation is found in Robert Neathery's book *West Plains As I Knew It*. He writes that Prosecuting Attorney Green told him many years after the explosion that "he had really tried to kind of hush the whole thing up." According to Neathery, Green feared that if a culprit had been identified, he would have been lynched by the angry citizens of the town. "Rather than probe too deep and get too many things going and letting everything get out of control, he said he just tried to soft-pedal the whole thing and hoped it would go away in time."

Eighty years later, historians are still pondering the mystery.

SOURCES

The text of W.J. Orr's letter was printed in the *West Plains Weekly Quill* of April 26, 1928.

All accounts of testimony of the various persons giving information to the coroner's jury were taken from the transcript of the testimony before the coroner's jury.

Robert Neathery's retelling of H.D. Green's attitude toward the investigation was from his *West Plains As I Knew It*. The quoted material from Mr. Neathery's book was used with the permission of Shawn Neathery Marhefka and publisher Marideth Sisco.

LEGALITIES AND
INDIGNITIES OF DEATH

The violent deaths of thirty-nine people stunned the families and friends of the victims and shocked the citizens of West Plains and surrounding communities. The inevitable legalities of death caused even more pain for those close to the victims, but only the estate settlements of Bob and Soula Martin, Kitty McFarland, Bob Mullins and Joseph Wiser received wide coverage in West Plains newspapers.

Blanche Martin, the only surviving member of her once happy, exuberant family, returned to West Plains from Memphis, where she was attending school. Her aunts, Mrs. J.W. Pumphrey and Mrs. Katherine Kellett; Dr. Louis G. D'Elias of Jersey City, New Jersey; and Mr. J. Fant Rogers accompanied Blanche to West Plains, where she claimed the bodies of her family. Representatives of the Davis-Ross Undertaking Company loaded the three coffins onto the Sunnyland Express train, and the distraught family accompanied them back to Memphis, where they were buried at Elmwood Cemetery. A few days later, Blanche returned to West Plains with her cousin, Percy Pumphrey, who had planned to stay with her in the Martin family home on South Street until the business of death was settled. The court had appointed her executrix of her family's estates.

In July, the *West Plains Gazette* advertised an auction sale by Blanche Martin of "all of my household goods" from the Martins' South Street home. The sale included a three-piece living room suite (wicker, overstuffed and walnut trimmed); a Circassian walnut dining room suite; a bird's-eye maple dresser and chiffonier; a "Sesola Victerola"; and an assortment of Italian rugs. The owner was listed as Blanche Martin Rogers. By then, Blanche had married J. Fant Rogers.

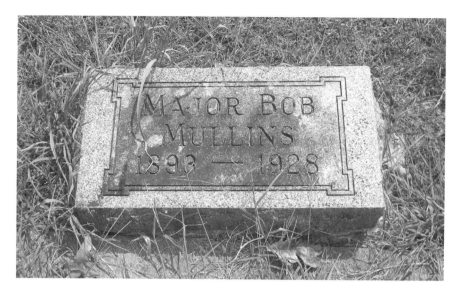

Grave of Bob Mullins at Oak Lawn Cemetery. *Photo by Lin Waterhouse.*

In October 1928, the Continental Insurance Company settled the life insurance policies held by the Martin family. Payment of the three policies, each in the amount of $1,250, was delayed because the insurance company contended that the policies did not cover death by explosion. The company had requested some determination of whether the Martins had died because of explosion, fire or collapse of the walls of the building.

The estate of Robert Mullins was still pending a full year after the explosion. Bertha Brazeal, Kitty McFarland's maid, had found a note in her employer's work basket in the amount of $3,000 signed by Mullins; however, the payee's line on the note had been left blank. H.J. Griffin, administrator of the McFarland estate, filed suit against the Mullins estate for the amount, contending that Mullins had borrowed money from Kitty to finance his business ventures. Two Howell County judges ruled in favor of the Mullins estate, but Griffin appealed and requested a change of venue. The case was moved to Rolla in Phelps County.

In March 1929, Cabool banker Steve Yates filed suit against the Mullins estate for $173.37 on a note dated January 22, 1917. Only $25.00 had been paid toward the balance. Probate Judge N.J. Ramsey denied the claim, but Yates gave notice of appeal to the circuit court.

In the months and years following the explosion, the matters of the estate settlements faded in the wake of the country's economic woes as it slid into

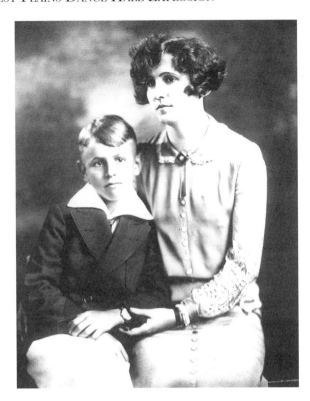

Mortuary owner Kitty McFarland died in the explosion, leaving her son Jack an orphan. *Courtesy of Jim and Cindy McFarland.*

the Great Depression. The author found no record of the final disposition of Mullins's estate.

The custody of the twelve-year-old orphan, John Henry "Jack" McFarland, created a courtroom circus. Interest in the boy was high because his family's history in West Plains was long and familiar to the community at large.

The boy's namesake was his grandfather. Born in Iron Mountain, Missouri, on September 13, 1860, Jack moved to West Plains in 1885 where he and Charles Dressler owned a hardware and furniture store. In 1886, McFarland wed his boyhood sweetheart, Egbertine "Bertie" Green, in Cuba, Missouri, and he and his bride settled in West Plains. The McFarlands faithfully attended the Episcopal church, and Jack was active in the Knights of Pythias, the Modern Woodmen and other fraternal organizations.

Eventually, McFarland settled on the mortuary business as his profession. When Missouri began licensing embalmers in 1895, McFarland was one of the first to pass the test. His embalmer's license was no. 28. Early in the twentieth century, McFarland opened what the *West Plains Daily*

Quill described as "West Plains's first exclusive undertaking and funeral directing establishment." McFarland equipped his funeral home with the latest equipment and personally handled every detail of services. He even journeyed to Kentucky to buy matched teams of fine English coach horses to pull his hearses.

Early in 1923, sixty-three-year-old Jack McFarland was diagnosed with spleen trouble following a case of blood poisoning. At first, the McFarland family was optimistic about a cure for Jack. In the 1920s, Nobel Prizes rewarded the discovery of human blood types, vitamins and insulin. The electrocardiogram diagnosed heart problems. Malaria, typhus, rickets and diphtheria had been conquered, and sulfa drugs were saving innumerable lives from bacterial infections. Confident in the medical achievements of the time, McFarland sought treatment at the Mayo Brothers Hospital in Rochester, Minnesota. However, he died only a few months later on July 5, 1923.

McFarland's funeral was memorable. West Plains businesses and government offices closed in his honor. Dozens of flower arrangements sent to the McFarland home nearly concealed the casket from view of the hundreds of mourners who gathered inside the house and on the lawn out front.

Three weeks after McFarland's death, his only son, Ray, was out on the town with three friends, celebrating one of their birthdays. Ray was driving his new Studebaker touring car at high speed down West Main Street when he lost control as he tried to pass another car. The vehicle skidded into a tree and across a bridge, overturning several times. The car came to a smashing halt at the bottom of a ditch.

The *Quill* reported that Ray's new car "turned over once or twice and then reared into the air, fairly standing on end" and "was reduced to scap [*sic*] iron. The top, the two front wheels, the hood, all, with the exception of the main part of the body, was litterly [*sic*] ground into splinters."

Ironically, the McFarland Undertaking Company's new ambulance transported Ray to Christa Hogan Hospital after the accident. Purchased only five months earlier, the specially constructed vehicle was a combination ambulance and sedan mounted on a huge Studebaker chassis. Seven passengers could ride in plush comfort in the sedan's gray leather interior. Within moments, it could be converted into an ambulance with a cot for the patient, large windows, a heating system and plenty of room for caregivers to administer to the sick or injured.

Ray McFarland died the morning after the accident in Christa Hogan Hospital. His companions, all badly injured, survived. The son's funeral almost duplicated the father's—just twenty-one days later.

In June 1924, almost a year after the death of her husband and son, Egbertine McFarland died of breast cancer at the age of fifty-seven. She had undergone surgery at the Mayo Brothers Hospital in Rochester, Minnesota, and radium treatments in Springfield shortly before her death.

Bertie McFarland was the great-granddaughter of Revolutionary War general Jacob Brown of New York and the granddaughter of General Egbert E. Brown, who commanded Missouri forces during the Civil War. To the people of West Plains, she had been known as "Mother" McFarland, a tireless worker for the Red Cross and the local Benevolent Association that cared for the less fortunate folks of Howell County.

After the three family deaths, Kitty McFarland and her son continued to live in the family home. The first licensed female mortician in the state of Missouri, Kitty took the reins of the family mortuary business and continued its successful operation. In the spring of 1928, she bought a large brick house on East Main Street and on April 12, 1928, announced plans to remodel it into the most beautiful funeral home in southern Missouri. One day after her public announcement, she was dead.

Immediately after Kitty's death, J.J. Griffin, a former probate judge, was named as administrator of her sizeable estate. Young Jack was her only beneficiary, and he suddenly became the sole owner of the McFarland Undertaking Company, the large house on Grace Avenue and his mother's $50,000 life insurance policy. Jack had previously inherited the $10,000 estate of his grandmother. Immediately after Kitty's death, Judge Ramsey of the Howell County probate court appointed Ed J. Green as Jack's guardian. Within hours, the court reversed itself and named Howard Kellett, vice-president of the First National Bank of West Plains, as guardian to the boy.

Green, a prominent wholesale grocer and banker from Mountain Grove, Missouri, and his wife, Maggie, applied to the court to adopt Jack McFarland. The Greens lived on a twenty-acre estate with a private swimming pool, tennis court and baseball field. Green was the foster brother of Bertie McFarland and had been part of the McFarland family for more than fifty years. He had, of course, known Jack since the day he was born. The court recognized the Greens' assertion that relatives of the boy had often expressed the desire for them to look after the boy if he were to need care and attention. They had lost two children to illness, and they expressed a strong desire to adopt Jack and raise him as their own. The Greens told the court that they viewed the adoption as an opportunity to raise a child with love.

In their petition to the court, the couple asserted that they were able to maintain and educate the boy and were of good moral character. They owned

a fine home, and they had ample finances to provide for Jack's future. They submitted that their adoption would be for the "best welfare of the child," and it would "be a pleasure and comfort to them to have the care and keeping of the child." They pledged to "do everything in their power to relieve him of the extreme sorrow brought about through the loss of his parents." Despite the value of Jack's estate, the Greens did not seek control of the boy's finances. Their interest was only to seek "the right to rear him and give him affection, education, a home and Christian training." They proposed a continuance of Howard Kellett's management and control of the boys' estate.

In June 1928, Howard Kellett, Jack's appointed guardian, also filed for custody. He cited a lack of jurisdiction on the part of the West Plains juvenile court to award Jack to the Greens. That same month, Silas Monger and his wife, Susan E. Monger, of Fort Worth, Texas, maternal grandparents of Jack, also filed for custody. Both Kellett and the Mongers requested a change of venue in the case.

On June 13, 1928, Judge E.P. Dorris convened a hearing on the matter in West Plains. The courtroom was packed with family and friends of the McFarlands. Principal witnesses were Ed J. Green, Howard Kellett, Silas E. Monger and the boy himself. Judge Dorris denied the requests for a change of venue, ruling that the hearing must be held in the county where the boy resided.

Ed Green testified that at the age of twelve, he had been adopted by Bertie McFarland's stepfather, Dr. Green of Cuba, Missouri. He testified that he and his adoptive sister shared an unusual "bond of love and devotion" that had endured their entire lives. Green's stated goal was to repay the kindness of his family by adopting Jack. He further testified that Kitty McFarland had conferred with him about the boy's education because Green's nephew, Clyde M. Hill, was a member of the faculty at Yale College. Further, young Jack had signed a petition agreeing to be adopted by the Greens.

Howard Kellett testified that he opposed the adoption of Jack by the Greens because he believed that the boy needed only a guardian. Under his authority as temporary guardian, he planned to send Jack to military school for the fall 1928 term.

Since the time of Kitty's death, Jack had celebrated his thirteenth birthday, and apparently his persona on the witness chair was strong. He told the court that he had at first refused to sign the agreement to be adopted by Mr. and Mrs. Green but that, after some time, he did commit to the adoption. However, by the time of the hearing, he had changed his mind again. Although he loved and respected the Greens, he preferred to stay in West Plains and not move to Mountain Grove. During much of

the hearing, Jack was absent from the courtroom riding a scooter on the sidewalk outside the building with some of his friends. At the conclusion of the hearing, Judge Dorris awarded Jack's custody to the Greens. The courtroom erupted with applause.

Six months later, the Springfield Court of Appeals reversed Judge Dorris's denial of request for change of venue by Howard Kellett and the Mongers. The appeal judge remanded the case to the Howell County Circuit Court for retrial. The new judge granted the change of venue. The case came up for a second hearing in Wright County, Missouri, in March 1929. At that time, the Greens withdrew their request to adopt Jack McFarland.

Ed Green's statement of explanation was printed in the *Quill*: "I have no doubt about the outcome of another trial, but I don't want to adopt Jack, even if it was the wish of his Grandmother McFarland that I look after his welfare, if Jack does not want to be a son to me. Neither do I want to adopt a boy who can be influenced by others than those toward whom he should show more gratitude." In court, Green further stated, "We do not want to adopt Jack if he does not want us to adopt him."

Apparently, the Mongers no longer pressed their custody claim, and the court granted the guardianship of McFarland to Howard Kellett. True to his early testimony, Kellett enrolled Jack in the Wentworth Military Academy, located in Lexington, Missouri.

Located close to Kansas City, Wentworth Military Academy is the oldest military academy west of the Mississippi River, and its campus is on the National Register of Historic Places. Established in the fall of 1880, Wentworth boasts a fine roster of graduates, including Ike Shelton, Missouri congressman; Robert Altman, Hollywood movie director; James Walton, founder of Walmart; and Marlin Perkins, host of the television program *Mutual of Omaha's Wild Kingdom*. Politicians, ambassadors, Pulitzer Prize–winning reporters, scientists and educators can name Wentworth as their alma mater.

Finally, there was the settlement of the estate of Joseph M. Wiser. According to her granddaughters, Virginia Graham and Barbara Morgan of Lebanon, Illinois, Clara Wiser was devastated by her husband's death. Married to Wiser at the age of fifteen, her entire life had been dedicated to her husband and their four children. Not only did she lose her husband, but she also suffered the humiliation of the whispers and stares of people within the community who believed that Joseph Wiser was responsible for the blast. A devout Christian, she never believed that her husband had caused the explosion and fire.

On May 3, 1928, the *Quill* reported that West Plains businessmen Vena Williams and Dr. T.E. Wilke were assuming ownership of Wiser's Oakland-Pontiac dealership. The article noted that the men's agreement with General Motors had been approved prior to the explosion. Many people believed that Wiser's loss of his General Motors affiliation was sufficient reason for him to blow up his garage—perhaps to collect on his insurance, to run away with Mrs. Lee or even to commit suicide. Although testimony before the coroner's jury seemed to discount those theories, public opinion blamed Wiser for the explosion.

The frustration of the Wiser family with the community's attitude was perhaps illustrated by a prank committed by Wiser's fourteen-year-old son, Paul Wiser, and Glenn Sams, the thirteen-year-old brother of Hugh Sams, who died in the explosion. On Friday, July 13, the community of West Plains was uneasy, remembering that the Bond Hall explosion had occurred on another Friday the thirteenth just three months earlier. The boys placed a large firecracker near the entrance of the Famous Theater, located on the northwest corner of the square in the Elledge Arcade. The resulting explosion created a near panic in downtown West Plains. Dean Davis, manager of the theater, chased the boys and apprehended them. He filed charges against Wiser and Sams in police court.

Wiser's family's attempt to collect on the insurance policy Wiser held with the National Fire Insurance Company of Hartford, Connecticut, became a public spectacle. The company refused to make settlement of Mrs. Wiser's $8,936 claim under the contention that Wiser himself had caused the loss. Mrs. Wiser filed suit in the circuit court in Kansas City, but the case was transferred to the federal court. Attorneys William Hogsett and Alvin C. Tripp of Kansas City and Will H.D. Green of West Plains represented the insurance company. Mrs. Wiser was represented by B.L. Rinehard and Jess M. Fisher of Kansas City and Homer Rinehard of West Plains. On October 17, 1928, twenty-five to thirty people testified about the explosion before Dan Buck, West Plains notary public. Witnesses included survivors and rescuers.

A small item in the May 23, 1929 *Gazette* reported that the case had been settled with a $500 payment to Clara Wiser. The amount, according to the newspaper, was half the $1,000 coverage that Wiser had carried on the cars parked in the garage the night of the explosion. Settlement of the case ended the public's optimistic speculation that more facts surrounding the explosion might come to light during the trial.

SOURCES

All details about the settlements of the estates of Bob and Soula Martin, Kitty McFarland and Major Bob Mullins came from newspaper reports of the time as noted.

The McFarland family history was recorded in the newspaper obituaries of Jack, Bertie and Ray McFarland, and the custody battle over Jack McFarland was covered by local newspapers. Jim McFarland, son of Jack, spoke with the author about his father's early years. He also provided an official copy of the court's decision awarding the custody of Jack McFarland to Howard Kellett.

Information about the settlement of the insurance claim by Clara Wiser was obtained from a *West Plains Weekly Quill* article dated October 18, 1928, and from a *West Plains Gazette* article dated May 23, 1929.

Information regarding the transfer of the General Motors franchise came from a *Quill* newspaper article dated May 3, 1928.

The story of the firecracker incident was found in an article in the July 19, 1928 *Gazette*.

THE COMMUNITY REBUILDS

Despite the intensity of the suffering caused by the deaths of thirty-nine people and the injuries to at least twenty more in the Bond Hall explosion, the community of West Plains squared its shoulders and fought to restore normalcy to the town.

A week after the explosion, the Pittsburgh Glass Company of Pittsburgh, Pennsylvania, delivered a load of plate glass to the merchants in the West Plains business district. The blast caused an estimated $2,000 worth of glass damage to windows on East Main Street, around the square and down Washington Avenue. Local glass dealer William Fitchett, who had been pulled from debris following the explosion, was unable to walk due to his injuries. Associates carried him to the downtown area, where he supervised the glass replacement.

In its April 26 issue, the *West Plains Weekly Quill* reported: "The broken glass has all been cleared away, and in the stores where the windows have been replaced, bright, beautiful displays have been re-arranged, and order has been completely restored throughout the establishments."

Within two weeks of the disaster, local women's groups had reordered supplies for Christa Hogan Hospital. The doctors had provided their services to the victims at no cost, and the community responded to the physicians' generosity and to the needs of the community's primary medical facility with alacrity. Christa Hogan Hospital had proved its value to the people of the Ozarks.

The ghastly scene of the explosion remained untouched until October 1928, when the chamber of commerce and the Business and Professional

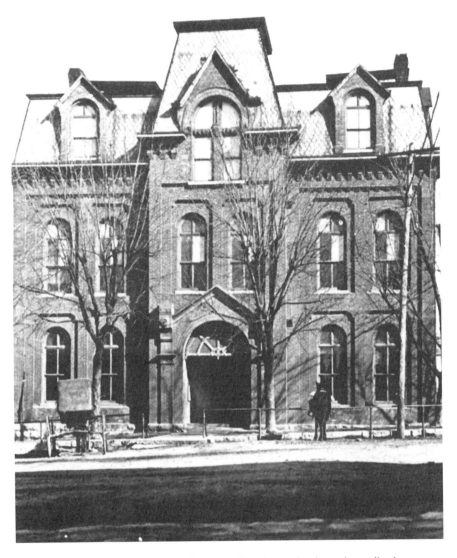

The explosion so damaged the Howell County Courthouse that it was immediately abandoned and finally demolished in 1933. *Courtesy of Toney Aid.*

Women's Club urged the owners of the properties to clear away the debris. Litigation by insurance companies wrangling over life and property insurance had delayed the cleanup. Finally, on October 25, the city provided workers and equipment, and the chamber of commerce donated

funds to clear the site. The property was cleared, graded and turned into a parking lot.

The old gothic courthouse in the center of the square had already been sagging with age in the spring of 1928, and the concussion from the explosion doomed the forty-five-year-old structure. All of the windows and some of the window frames had been blown from the building. The bulging eastern walls measured five inches out of alignment, and the northern and southern walls were cracked and out of plumb. Inspectors recommended bracing all four sides of the building to prevent its immediate collapse.

Within days, officials decided to move all of the offices from the courthouse, choosing the vacant Methodist-Episcopal church on Washington Avenue as an interim facility. Officials rented temporary quarters for the offices of the probate court and the prosecuting attorney, and within days the business of the county had resumed. Court clerks continued to work short shifts in the building despite ominous cracking and popping noises emanating from the shaky structure, and additional cracks and bulges materialized with every breath of wind. Walls separated from floors, furniture shifted and doorways yawed precariously. Finally, on October 3, 1928, workers gingerly removed the precious court records to their new home in the church basement.

On June 21, 1928, the *Quill* reported that Springfield architect Earl Hawkins had submitted drawings for a new courthouse. The proposed facility measured 115 feet by 75 feet and was three stories high. Colonial-style cut-stone pillars distinguished the front of the building. The cost was estimated to be $99,000. Hawkins had been instructed to design the building to be completely fireproof, with a metal roof and windows and concrete and terrazzo floors. Provisions were made for county courtrooms and offices on the first and second floors and for the jail on the third floor.

After thrifty voters defeated a bond issue to build a new courthouse in June 1929, county officials shelved the plan that autumn to wait out the Depression.

In January 1933, almost five years after the explosion, the chamber of commerce finally established a fund to raze the wreck of the courthouse that blighted the square. Two years later, the Howell County Court allowed the City of West Plains to beautify the area with a park that included new walkways, flowers, shrubs and a fountain.

In June 1935, federal assistance became available to help the city build a new courthouse, and in November voters approved a $50,000 bond issue to be matched by a $45,000 federal grant. The county again called on Earl Hawkins, who designed an austere, three-story, eighty-two-foot-square

facility constructed from Carthage stone that was completed in June 1937 at a cost of $107,000.

While Howell County officials grappled with the issue of the courthouse, West Plains' city fathers initiated a new era of fire protection. On April 12, 1928, the day before the disastrous explosion at Bond Hall, the city had announced plans to purchase new firefighting equipment, specifically a hose truck and a chemical engine. City fathers wanted to upgrade the city's response to fires and lower the insurance rates through a higher level of preparedness.

In May 1928, the city invited the members of the Missouri Fire Prevention Association to hold their annual convention in West Plains. Fifty insurance agents convened in the city to promote proper construction codes to prevent fires, inspect the business district for hazards and launch a fire prevention program through the schools.

Immediately following the visit from the Missouri Fire Prevention Association, Commissioners Earl Armstrong and Carac Davidson traveled to Kansas City to view the newest in fire trucks and equipment. Gus Joliff, who had recently retired after twenty-five years with the Shreveport, Louisiana fire department, accompanied them. Joliff had written to the city immediately following the explosion to praise the city's firefighting efforts during the Bond Hall tragedy. The officials' trip resulted in the purchase of a new American LaFrance fire truck with complete equipment, including an eighty-gallon booster tank, a five-hundred-gallon-per-minute pump, two hand-held fire extinguishers, 1,200 feet of fire hose and ladders, axes, lanterns and other apparatus, according to the May 24, 1928 issue of the *Quill*.

On May 31, West Plains' mayor, commissioners and chamber of commerce members announced the adoption of tough new fire prevention ordinances that carried stiff fines and penalties for violations. On that same day, the editors of the *Quill* bemoaned the sad fact that the changes to the fire prevention code had come too late to prevent the disaster at Bond Hall: "Such a set of ordinances would have prevented the terrible tragedy which befell West Plains last month, costing the lives of many of the city's valuable citizens and resulting in the injury of many others," wrote the editors. "No one in West Plains had ever thought of the danger lurking in the hall above the Wiser garage where social gatherings of many kinds were held and where many banquets have been held at which almost every business man in the city was present."

Gus Joliff was appointed the city's first full-time fire chief, replacing Jake Palmer, who was commended for the seven years he had worked on an on-call

The city purchased a new American LaFrance fire truck following the explosion. *Courtesy of Toney Aid.*

basis. Palmer assumed the position of assistant to Joliff, and Floyd Arnhart was named master mechanic to the new department. Chief Joliff was in charge of the station every day and two nights in each week, and Bert Woody was in charge the other five nights, providing twenty-four-hour coverage and eliminating the time previously lost by firemen rushing to the station for the fire truck.

In October 1928, a benefit banquet honored the city's firefighters and raised more than $200 for equipment. "Peace hath its victories no less than war," Dewey Short, the featured speaker, told the gathering, "and men who were willing, as are the home firemen, to risk their lives in the line of public duty are no less patriotic than are those who don the uniform in the country's hour of peril."

SOURCES

The glass cleanup was detailed in the *West Plains Weekly Quill* of April 26, 1928, and the efforts of the local women's groups to replace supplies at Christa Hogan Hospital were reported by the *Quill* on May 3, 1928.

The chamber of commerce and Business and Professional Women's Club's effort to clean up the site of the explosion was covered in the *Quill* of October 18, 1928, and October 25, 1928.

Information about the abandonment, razing and rebuilding of the courthouse was derived from the following sources: *West Plains Gazette* of April 19, 1928; April 26, 1928; March 28, 1929; April 25, 1929; June 20, 1929; June 27, 1929; July 11, 1929; March 21, 1935; and July 18, 1935; *West Plains Journal* of April 19, 1928, and September 12, 1929; and the *Quill* of May 3, 1928; May 10, 1928; May 31, 1928; June 21, 1928; October 4, 1928; April 25, 1929; May 23, 1929; June 27, 1929; July 1, 1929; January 5, 1933; and February 9, 1933.

The history of the courthouse was reported on the website of the University of Missouri Extension, "Howell County Courthouse," http://extension.missouri.edu/publications/DisplayPub.aspx?P=UED6045; and the University of Missouri Extension, "Howell County Courthouse," Marian M. Ohman, Department of Community Development, http://extension.missouri.edu/explore/uedivis/ue6045.htm.

The story of the development of modern fire prevention in West Plains was detailed in the *Quill* of April 12, 1928; May 17, 1928; May 24, 1928; May 26, 1928; May 31, 1928; October 11, 1928; and June 14, 1928.

The history of the West Plains Fire Department came from the *Quill* of September 20, 1928, the *Journal* of October 18, 1928, and the website for the West Plains Fire Department, www.westplainsfd.org.

CONSEQUENCES OF TRAGEDY

After seeing and hearing friends and loved ones trapped under bricks and beams while a firestorm raged around them, the people who managed to extricate themselves from the debris faced the agonizing choice of staying in the fiery wreckage to attempt to rescue others or fleeing to safety. Those decisions must have haunted the survivors for the rest of their days.

Within minutes of the explosion, rescuers converged on East Main Street, and bystanders, firemen and police officers braved the dangers to pull the living and the dead from the skeletons of the Ward, Riley and Adams Buildings. Heroes in spirit and courage, some of those men became victims, too. Today, search and rescue professionals train in self-protection against physical and mental injury, and that education and experience helps to desensitize them to the human tragedy. However, the men who rushed to the aid of the Bond Hall victims had no such training. They sustained burns, bruises and lacerations that faded more quickly than their memories of the dead and dying.

According to modern-day psychologists, human beings need to believe that the world around them is predictable, orderly and within their control. At 11:05 p.m. on April 13, 1928, the confidence of Ozark residents was shaken by chaos, terror and grief. Although the physical injuries of the survivors of the explosion were severe, the psychological wounds could have been just as crippling and even more insidious to overcome.

"Victims of disasters experience physical harm combined with emotional, relational and psychological trauma, anguish and suffering both immediate and long term," advises Minneapolis, Minnesota psychotherapist Susan

Holladay. The emotional trauma would have radiated out from the victims to the rescuers, loved ones, friends and acquaintances who grieved for the lost and injured, according to Holladay.

"Psychic numbing, emotional anesthesia and diminished interest in previously enjoyed activities" often follow a traumatic experience, according to Garet Waterhouse, licensed clinical social worker from Fort Bragg, California. Victims often attempt to forget or repress the traumatic moments, but survivors retain memories of the sound, smell, taste or feel of the explosion, and these sensory recollections become "flash frozen" in the survivors' brains like random pieces of a puzzle. Although these remembrances may be internalized, says Waterhouse, they never go away. Over a lifetime, an odor, a visual image, a sound or a touch might trigger a memory of those terrible moments.

In recent years, psychologists have learned a good deal about mass trauma. The tragedies of September 11, 2001, the Madrid train bombing of 2004 and Hurricane Katrina in August 2005 provided a wealth of information about the immediate reactions and long-term physical and mental health concerns of people following a disaster. However, in 1928, the survivors, families and friends of the victims of the Bond Hall explosion simply struggled on through life.

Following an injury or death, people experience a healing process, identified as the five stages of grief by Dr. Elizabeth Kubler-Ross. Initially, we deny the loss and feel isolated and lonely in our grief. Secondly, we experience anger—with ourselves for not protecting our loved ones, with officials who failed to pass preventative laws, with God for allowing a tragedy or even with the dead who caused us such pain. Next, we bargain with God to erase the tragedy. A sense of depression accompanies the feelings of sadness and anger until we finally acknowledge and accept our loss.

The stress of dealing with the conflicting emotions of anger, frustration, loneliness, guilt, anxiety and depression can be crushing. An individual best passes through these stages with the help of a supportive circle of family and friends who encourage the grief-stricken person to care for himself with regular habits such as balanced meals, hydration, exercise and rest. If the cycle to acceptance is not completed, an individual can continue to suffer intense pain for weeks, months or a lifetime.

While this process is well documented in individuals grieving a death, evidence exists that communities and societies follow this same psychological path. The stronger the human, spiritual, societal and organizational bonds within the community, the better its citizens handle a disaster.

The tightly woven fabric of West Plains' society both compounded and assuaged the pain. In the small town of fewer than 3,500 people, where families had lived together for generations, hardly a home was spared the loss of a loved one. Most of the dancers had known one another since childhood, and their names and faces were familiar to almost everyone within the grief-stricken community.

That human network of relationships also aided the survivors and the heartbroken families of the dead. A village of love, consolation and support embraced the mourners. Hospital staff and volunteers cared tenderly for patients without thought of remuneration, and extended family members rushed to comfort their own. Survivors, relatives and friends aired their memories and grief to newspaper reporters and to the members of the coroner's jury in a professional and business-like atmosphere that provided emotional release but discouraged hysteria. Memorial services were opportunities to grieve—as many as seven thousand mourners attended the service for the unidentified dead at Oak Lawn Cemetery. Most of the dead had been members of churches, and the majority of local religious institutions soothed the mourners with the assurance that their loved ones were safe with God.

"[In 1928] religion was one of the few American cultural institutions providing a direction, plan and a social community to maintain hope, meaning and a positive vision for people in the face of suffering, pain, illness, death and despair," says Susan Holladay. "Then and now, religion and religious community provide strength, comfort and meaning to people in their suffering."

While most clergy in West Plains honored the dead, some conservative, fundamentalist preachers proclaimed that God had exacted vengeance on the sinful dancers in a hell of fire. Literature demonizing the victims flooded into West Plains. Many leaders within the community, including the editors of the *West Plains Daily Quill* and the *West Plains Gazette*, decried the fanatical beliefs, but people were desperately seeking explanations for the tragedy. Since the coroner's jury offered no explanation for the explosion, folks opened their minds to other voices.

According to psychologists, people who are reeling from a disaster often reassess their values and lifestyles to reestablish a path to a safe existence. Determining the tangible or spiritual meaning of a traumatic event aids people in fitting together the broken pieces of their lives into a secure, controllable whole. For some persons, accepting the idea that God struck down a dance hall of sinners was a simple, if simplistic, answer for the tragedy.

In an article in the April 13, 1978 *West Plains Daily Quill*, reporter Jim Cox wrote that no public dances were organized for many years following the disaster. A more conservative populace rejected the philosophy of the fun-loving, spirited young dancers, and some folks even vilified the Bond Hall victims as irreverent or immoral. One elderly resident of West Plains told this author that his aunt usually attended the dances—that she was "pretty wild" in her younger days. Leona Jenkins, a member of the Wiser family, recalled folks saying that "bad things happened at dances," citing the Bond Hall tragedy as an example of God's displeasure with dancing. The attitudes of the community must have saddened and frustrated the survivors and loved ones of the dead. Not surprisingly, few spoke of the disaster, and most refused to discuss their sorrow. Just as the story receded from the pages of local newspapers, folks hid away their grief and struggled on.

The blast snuffed out many from a generation of progressive leadership for West Plains and southwest Missouri. The victims were educated and ambitious young citizens, the children of the community's most prominent families. Almost to a person, they were future leaders—budding lawyers, educators and businesspeople.

The contributions the victims might have made in West Plains is, of course, incalculable: the number of young women inspired by Kitty McFarland's business acumen or Soula Maxey Martin's political and professional activism, educational and personal influences on students by Icie Risner and Hazel Slusser or dairy science innovations that might have been developed by Paul Evans and his partner. Elbert and David White might have grown their bus service into an Ozarks transportation empire. To extrapolate further, consider the social impact of vivacious, musically talented Billy Drago's never-born children. The metaphysical guessing game plays out in myriad directions.

Fundamentalist religious voices denounced the lighthearted, spontaneous society of the 1920s, preaching that the sinful lovers of dance had been struck down by God. No one knows the number of individuals who changed their beliefs and lifestyles and warned their children about God's wrath. Sadly, some mothers and fathers must have lived out their lives believing that their children burned in hell because they attended the April 13, 1928 dance at Bond Hall.

SOURCES

"Coping with a Traumatic Event." Centers for Disease Control and Prevention. http://www.bt.cdc.gov/masscasualties/copingpub.asp.

Garet Waterhouse, LCSW, is a family therapist practicing in Fort Bragg, California.

Heinberg, Richard. "Catastrophe, Collective Trauma and the Origin of Civilisation." *New Dawn Magazine*, no. 55 (July–August 1999). Australia and New Zealand. www.newdawnmagazine.com.

Kingman, Avignor, and Esther Cohen. *School-Based Multisystemic Intervention for Mass Trauma.* New York: Kluwer Academic/Plenum Publishers, 2004.

"The Kubler-Ross Grief Cycle." Argosy University, 2002–2009. http://changingminds.org/disciplines/change_management/kubler_ross/kubler_ross.htm.

"The Stages of Grief." Memorial Hospital, Inc. Towanda, Pennsylvania, 2006. http://www.memorialhospital.org/Library/general/stress-THE-3.html.

Susan Holladay is a psychotherapist practicing in Minneapolis, Minnesota.

Ursano, Robert J., Brian McCaughey and Carol S. Fullerton. *Individual and Community Responses to Trauma and Disaster.* New York: Cambridge University Press, 1994.

BEYOND THE TRAUMA

Although life would never be the same for the families and friends of the victims of the explosion, most folks heard those Ozark fiddles wail. Like their rugged ancestors, they accepted the vagaries of fate, gathered up the shreds of their lives and forged on. In April 1929, the first anniversary of the explosion was marked by memorials to the lost in the *West Plains Daily Quill*.

The Reverend J.F.E. Bates remembered his eighteen-year-old son with a prayer: "Through this fellowship of love and suffering, we trust we have come to know Him, who is the friend of all better, and He has become more real. The clouds are gradually lifting, there appears a rift, that is certain, and the brightness of the face of the Son of God shines through."

"In Memory of Dimple, my sweetheart, my friend, my pal, and the sweetest girl known in my life," wrote Paul Goodall. "May her soul be ever in peace and God have mercy on her loved ones left behind."

The choir of the All Saints Episcopal Church offered its memoriam: "In Loving Memory of Frances (Billy) Drago, Kitty McFarland, and Nellie James Murphy, all of whom passed on one year ago tonight. Never forgotten."

Blanche Martin Rogers, who lost her entire family in the explosion, wrote: "In loving memory of my dear father, mother and sister, Robert Gaines Martin, Soula Maxey Martin and Soula Gaines Martin, who passed on one year ago today."

Such memory pieces would appear for years to come in April on the anniversary of the explosion or on Decoration Day (now Memorial Day) in May.

Grave of Joseph Wiser, who was widely suspected of causing the blast. *Photo by Lin Waterhouse.*

A year after the explosion, Ruby Hodkinson's husband, thirty-one-year-old Clifford Hodkinson, became the fortieth casualty of the explosion when he committed suicide. Even after a year of grieving, he could not cope with the horror of his wife's final moments. While visiting his parents in Kansas City, he wrote a note explaining his sorrow and then fatally shot himself. Four-year-old Clifford Hodkinson Jr. was left an orphan. The boy was sent to live with Ruby's father, Otis Warren, in Springfield.

The family of Joseph "Babe" Wiser was forever changed. John Barton is the son of Wiser's daughter, Clara Vivian Barton. From his home in Alton, Missouri, he recalled that his grandmother, Clara Wiser, supported herself and her boys as a laundress and housekeeper. She was a devout member of the Assembly of God Church in Alton, even preaching the gospel. Barton said that within the family, Wiser was regarded as a "nice, jolly fellow, a hard worker and a good manager." The family rarely discussed the explosion. Anyone who brought up the subject of his grandfather's death was told, "Let it be."

Leona Jenkins was married to Clara Wiser's nephew, Wallace Jenkins, for fifty-seven years. Prior to her marriage and still living with her parents in Texas County, Missouri, she remembered that Jenkins canceled a date with her to attend his uncle's funeral. According to Jenkins, people who

knew Wiser never believed that he caused the explosion. Although many people opposed dancing in the 1920s, Jenkins believed that only a fanatic would have committed such a heinous act, and she did not believe that any members of the Wiser family were fanatics. She said that Clara Wiser was a "good and truthful woman" who never got over her husband's death.

Virginia Graham, daughter of Joseph Wiser's son, Paul Fred, adored her grandmother. She remembered that Clara made school clothes for the children in the family and loved to spend time with her grandchildren at the Alton farm of her daughter, Vivian Barton.

"She was a good person," Graham said of her grandmother. "She loved the Lord."

Graham recalled being told that her grandfather had been shot in the head the night of the explosion and that the family always believed he was a victim of the explosion. Family members rarely discussed Wiser's death, according to Graham, because her aunt Vivian Barton would "go to pieces" if the subject was brought up.

Even at an advanced age, Clara Wiser opened the little Assembly of God Church in Alton for evening services. One snowy night, while walking to church, she slipped on ice and broke her hip. She was confined to Chastains of Thayer Nursing Center until her death at the age of eighty-six.

Graham also rejected the assumption that her grandfather's attitude toward dancing caused him to stage the explosion. She recalled a story from her childhood that illustrated the way the Wisers followed their beliefs. As a child, Graham wanted to learn to tap dance—just like the actress who lived next door to the family's home. Instead, her conservative parents sent her and her sister to piano lessons. The lessons to which Paul and Mary Wiser sent their girls paid off, because Virginia Graham and her sister, Barbara Morgan, formed a gospel singing quartet with their husbands and entertained audiences throughout the Bible Belt states for many years. Graham believed that no one in her family would have harmed a person because of his or her religious beliefs.

For eight decades, the Wiser family has been haunted by the question of their grandfather's culpability in the explosion. When the author contacted Barbara Morgan and told her of the book project, she said, "You're the answer to a prayer." She and her siblings believed that a complete retelling of the events that led to the disaster would establish their grandfather's innocence.

After the explosion, Glen Moore left his job with the Reed-Harlin Wholesale Grocer Company, where he had worked with Lev Reed, and

he went to work for the McBride Drug Company. By October 1928, he had accepted a position with the Granite City Steel and Iron Company in Granite City, Illinois.

Glen rekindled his relationship with Helen McCallon, but her parents believed that their daughter was too young to be serious about a man, even a hero like Moore. That fall, McCallon accompanied her uncle Clarence C. McCallon (who had served on the coroner's jury investigating the explosion) and her cousins, Elizabeth McCallon and Guy F. McCallon, on a trip to St. Louis. The two young women slipped away from the group and crossed the Mississippi River into Illinois, where Helen and Glen were married on October 15, 1928, at the First Presbyterian Church of Edwardsville. Elizabeth McCallon and Lloyd Forest, Moore's cousin, served as witnesses. The elopement was apparently planned, because the groom had a furnished apartment in Granite City already prepared for his bride.

After the Moores returned to their hometown, Glen prospered as a businessman, owning a Standard Oil of Indiana service station on Washington Avenue. According to his daughter, Carol Moore McInnis, his primary loves were his family, his farm and the Democratic Party.

Mrs. McInnis recently retired to Columbia, Missouri, after a career as a magazine editor in Indianapolis, Indiana. Her brother, Bob Moore, lives in West Plains, and her sister, Virginia Moore McMillan, resides in Columbia. The siblings recall a happy small-town childhood overseen by loving parents. McInnis remembers that her father rarely spoke of the explosion. However, her sister-in-law, Cindy Moore, recalls that as he aged, Moore reflected on the tragedy. She said that her father-in-law would pause frequently as he spoke, "often looking down at his interlocked fingers and sighing, as if he were reliving that night."

Eugene Smith, the deaf-mute known throughout West Plains as "Dummy" McFarland, went to live with his sister, Nancy Wade, after the explosion. According to an obituary given to the author by Jim McFarland, Smith often strolled the alley behind the McFarland house, gazing longingly at his former home. When he would meet friends of the McFarlands, he would gesture as if stroking long hair, his sign indicating his memory of Egbertine McFarland. Then, with a solemn shake of his head and more gesticulations, he would indicate that all the family members except young Jack were sleeping in the cemetery. Smith died in 1930 in the home of his sister.

Fifty years after the explosion, Fern McBride remembered only "a blinding white light, the deafening blast and being hurled up and up." From

Fern McBride, with parents Tom and Ella Pumphrey, shortly after the removal of her full-body cast in 1929. *Courtesy of Steve McBride.*

her home in Fresno, California, she sent a letter to Russ Cochran, editor of the *West Plains Gazette*, in response to a 1978 article about the explosion.

"My husband and I were so fortunate to live and be blessed with these following 50 years that I have made a very special effort to bury the memory of April 13, 1928 and go on with the business of a happy marriage blessed with two children and four grandchildren," McBride wrote.

Fifty years after the disaster, she admitted, "When I reach back to recall those moments of horror, that traumatic feeling still engulfs me."

McBride preferred to focus on the kindnesses shown to her during the weeks when she was a patient at Christa Hogan Hospital, where she lay encased in a plaster cast, suffering from four fractures of her spine and a badly crushed left leg and ankle. She praised the work of Drs. Hogan and Toney and was grateful for the courage and compassion of Reverend Bates, who visited her often despite his own personal loss of his son John, who had been the McBride's dinner guest that evening.

According to Steve McBride, grandson of Garrett and Fern McBride, his grandparents did not like to discuss the explosion.

Fern and Garrett
McBride, about 1952.
Courtesy of Steve McBride.

"When I was a small child, I remember asking my grandmother why her
ankle and foot were so bumpy," said McBride, "and she replied that there
were little pieces of brick still in her foot from a bad accident as a young
woman." McBride, who lives in Fresno, California, told the author that his
family moved west after the loss of their drugstore in the Depression. He did
not learn the details of his grandparents' close escape from Bond Hall until
the fall of 2008.

"I recently discovered many of my grandparents' old family records when
a suitcase containing them was discovered after being 'misplaced' for twenty
years," he told this author.

McBride remembered that he was in his twenties when his grandmother
read the *Gazette* article about the explosion, and she was "distressed about
having to relive it in her mind."

"My grandparents lived a full life after the accident, but with many
physical and mental scars," said McBride. "They both died in 1989, and I

Fern and Garrett McBride on their fiftieth wedding anniversary in 1976. *Courtesy of Steve McBride.*

know [they] suffered from the continuing pain and memories of this tragedy their entire lives."

After Jack McFarland graduated from Wentworth Military Academy, he attended Northwestern University in Evanston, Illinois, and Missouri University (MU) at Columbia. At MU, Jack met a pretty journalism student, Mary Jane Norton from Liberty, Missouri. Norton was from a fine Clay County family, and her grandfather was a U.S. congressman who served as chief justice of the Missouri Supreme Court. Jack and Mary Jane were married in 1936. The young couple settled in West Plains, where Jack worked in Howard Kellett's bank, but Jim McFarland said that his father really did not care for the work.

After the Japanese attack on Pearl Harbor, Jack enlisted in the army, where his military training at Wentworth served him well, securing him a commission as a second lieutenant. As a captain in the First Army, Sixty-ninth Division in the European theater, he was awarded the Bronze Star

and the Combat Infantry's Badge. According to Jim McFarland, his father went through a difficult period of adjustment to civilian life after the war. He refused to return to the bank and secured work as a cattle herder for a ranch near Salem, Arkansas. For a year or two, he herded cattle from Arkansas to the sale barn in southern Missouri.

Eventually, McFarland returned to the First National Bank of West Plains, retiring as president and chairman of the board. A recognized civic leader, he served as president of the West Plains School Board, the West Plains Chamber of Commerce and the Ozarks Development Corporation. He was active in the Rotary Club and in various banking organizations throughout Missouri.

Jack and Mary Jane McFarland raised four children. The eldest boy was named John Henry Jr. after his father and great-grandfather. Daughters Kitty, Ann and James Ray rounded out their family. According to Jim McFarland, his father rarely spoke of the explosion that altered the course of his life.

"I think he didn't know how to process that [experience] at all," said McFarland. "That whole era of people found it difficult to express their feelings."

Kitty McFarland's name and memory live on within successive generations. Jim and his wife, Cindy, named their daughter Mary Katherine after her great-grandmother.

After Jack McFarland's death in January 2001, Frank L. Martin III, editor and publisher of the *West Plains Daily Quill*, eulogized McFarland as a "giant" of a man. He fondly remembered the gentlemen banker who "loved the outdoors, and was an avid hunter and fisherman." Echoes of Jack McFarland's father, the fun-loving Ray McFarland, resound as Martin wrote of the banker's lighter side: "Jack McFarland was fond of a bawdy joke or story, and was known to enjoy a whiskey and some branch water now and again."

Had she lived to see her son become a man, surely Kitty McFarland would have been proud.

In the years following the explosion, newspaper stories detailed the lives and fortunes of others intimately affected by the tragedy.

On May 31, 1928, the *West Plains Daily Quill* endorsed Will H.D. Green for reelection to the position of prosecuting attorney for Howell County. The recommendation cited Green's "unquestioned ability" and careful investigation and prosecution of every violation. No mention was made of his part in the inquiry into the explosion that had occurred only two weeks earlier. Green was appointed circuit judge in October 1928.

Jack McFarland. *Courtesy of Jim and Cindy McFarland.*

Leonard Fite, Wiser's salesman at the time of the explosion, died in October 1938 at Cottage Hospital following surgery for a ruptured appendix. According to the obituary, Fite had been born and raised near Bly, Missouri, and had come to West Plains eleven years earlier, apparently just prior to the time he went to work for Wiser, although no mention of his time at the garage was included in his obituary. He had been employed at the West Plains Bakery for five years, and he and his brother Alvin Fite had operated an auto salvage shop in West Plains for the five years prior to his death.

The March 28, 1935 obituary in the *West Plains Daily Quill* for Jim Jewell, Wiser's mechanic, reports that he died of tuberculosis only seven years after the explosion.

Frank "Daddy" Poole, who cheated death during the Civil War and in the explosion of Bond Hall, died in his home on November 7, 1935, at the age of eighty-nine. In his obituary, he was remembered for his love of discussing current affairs, reading and playing the games of checkers and pitch.

C.R. "Babe" Lashley, whose friends and family came under suspicion because of Wiser's testimony against Lashley, returned to West Plains after he completed his prison sentence. He became a successful automobile dealer and died in 1973 following an extended illness.

Bront Luna, the high school student who was sitting on the steps to Bond Hall at the time of the explosion and who saved the life of Dail Allen, graduated from West Plains High School and attended the Kansas City Western Dental College. He served in World War II as a flight engineer on B-24 bombers, and he was one of the original employees hired by the Arco Space Center at Cape Kennedy, Florida, where he worked for many years. He and his wife, Geneva, had two children, Bront Jr. and Rita. He died on November 20, 1985, at the age of seventy-five.

Mayor James Harlin served a total of thirty-two years as mayor of West Plains. For many years, his tenure as mayor (1906–8 and 1924–44) was a national record. Harlin died in December 1946 at the age of eighty-four.

Dail and Dorothy
Allen, about 1980.
Courtesy of Dorothy Allen.

Dail Allen, the teenage horn player who landed on the sidewalk still holding his trumpet, graduated from West Plains High School in 1931 and attended Southwest Missouri State University. He married Dorothy Powell at Salem, Arkansas, and they had one son, James Dail Allen. Allen was self-employed, selling advertising specialties. He was active in numerous social activities and was an avid golfer. Uncharacteristic of many of the Bond Hall survivors, Allen frequently shared his memories of the explosion throughout the years. He died at age eighty-one in 1993.

Carla Mullins Burns was named after her father, Carl Mullins, the drummer in the three-piece musical combo. According to his daughter, Mullins suffered serious injuries in the blast, including permanent blindness to his right eye. His pregnant wife, Naomi, died in the disaster.

Mullins and Hazel Robertson eloped to Arkansas in 1929, but poor economic times plagued the newlyweds. After moving to Virginia to live with Mullins's sister, Hazel found work in Washington, D.C., and Mullins soon joined his wife. Carla Burns remembers frequent visits to her father's family in Burnham, Missouri. An accomplished piano player, he played a "slide style, jazzy ragtime." One of his daughter's most prized possessions is her father's drum with "Moon Mullins" printed on the side.

Carla Burns recalled that her father rarely spoke of the disaster until shortly before his death in September 1987, when Mullins confided some of his memories of that night to his granddaughter.

Charles Drago never knew his aunts, Frances Wilhelmina "Billy" Drago and Susan Virginia Drago Rogers, and his family rarely spoke of their painful loss. Susan's daughter, Patricia, who was visiting Grandmother Drago in West Plains with her mother at the time of the blast, returned to Kansas to live with her father, Wallace Rogers. Charles Drago told this author that the family kept in touch with Patricia and, later, her children and their families for many years. After speaking about the explosion to this author, he resolved to reconnect with them.

Charles Drago is now owner of the Robertson-Drago Funeral Home located on West Main Street in the building purchased by Kitty McFarland in the spring of 1928 to be converted into the most beautiful funeral parlor in the Ozarks.

In May 1928, a group of West Plains businessmen bought the McFarland Undertaking business for $6,800 at auction. Paige and Dorothy Robertson, longtime employees of the McFarland family, continued to operate the business for the new owners. Dorothy Robertson was the sister of Billy Drago and Susan Drago Rogers. In the 1940s, the Robertsons assumed ownership

Granite memorial to the unidentified dead in Oak Lawn Cemetery. *Photo by Lin Waterhouse.*

of the West Main Street mortuary, naming it the Robertson-Drago Funeral Home, the name it retains today.

The granite memorial erected to the memory of the unidentified victims of the explosion at Oak Lawn Cemetery became legend for its propensity to periodically slip off its base. Rumors abounded about the stone being moved by the restless spirits buried beneath it. Some folks described the stone as "dancing" off its base. According to West Plains resident Sharon Orlikowski, when she and her sister were teenagers in the 1960s, groups of young people would congregate at the memorial at night in hopes of viewing ghostly activity around the monument. "Scaring ourselves to death," Orlikowski explained with a smile.

West Plains author and historian Dorotha Reavis linked the movement of the memorial to the huge diesel trains that traveled the tracks near the cemetery. Once they no longer chugged into West Plains, the monument stopped dancing.

For a time, the owner of a music store on the square commemorated the explosion by setting up a phonograph on the sidewalk outside his business and playing a recording of "At Sundown," the last song played in Bond Hall. He stopped after he received complaints from the public.

"The West Plains Explosion," a song written by Vernon Dalhart, memorialized the disaster. It was included on Dalhart's album of music, "*The*

The West Plains Explosion

VERSE 1: In a little town of West Plains/In old Missouri state/'Twas in the month of April/They saw the hand of fate

VERSE 2: The springtime flowers were blooming/The world was bright and gay/And no one dreamed the danger/Would come to them that day

VERSE 3: Was there the young folks gathered/One fatal Friday night/And to the dance they wandered/With hearts so gay and light

VERSE 4: And there they spent the evening/Without a thought of fear/For nothing came to warn them/That death was drawing near

VERSE 5: The dance was nearly over/The evening nearly past/When from the floor beneath them/There came an awful blast

VERSE 6: The building all around them/Came tumbling to the ground/And there they fought and struggled/But the hot flames beat them down

VERSE 7: How quick the scene was shifted/From one so gay and light/How hard the brave men strug-

gled/To save their friends that night

VERSE 8: How sad the fears of loved ones/Who came at break of dawn/To see the great disaster/Where forty lives had gone

VERSE 9: We can't explain the reason/These awful things must come/But we should all be ready/To say, "Thy will be done"

VERSE 10: And though our hearts are weary/Our burdens hard to bear/We have one consolation/We'll meet them over there

Cat. #0113 (MFH #683) – As sung by Mrs. Sam "Iva" Haslett, West Plains, Missouri on June 11, 1958 (from the Max Hunter Collection, Missouri State University Library)

The song "West Plains Explosion" by Vernon Dalhart. *Courtesy of Ozark Mountaineer magazine and the Max Hunter Collection, Missouri State University Library, Springfield, Missouri.*

Wreck of the Old 97" and Other Early Country Hits (Volume III). Several versions of the song were released on the RCA Victor and Decca labels. The song begins, "In a little town of West Plains / In old Missouri state / 'Twas in the month of April / They saw the hand of fate." The song is preserved in the Max Hunter Collection at the Missouri State University Library in Springfield, Missouri.

SOURCES

Hearing "those Ozark fiddles wail" refers to a comment by historian Don Holliday in the documentary *The Ozarks: Just That Much Hillbilly in Me.* The context of Holliday's remark can be found in the second chapter here, "West Plains: The Gem City of the Ozarks."

The West Plains Public Library's collection of microfilms of old newspapers was the source of most of the historical perspectives for the

explosion. The memorials to the dead on the first anniversary of the explosion appeared in the April 18, 1929 *West Plains Weekly Quill* newspaper.

The suicide of Clifford Hodkinson was detailed in the May 23, 1929 issue of the *Quill* and the May 23, 1929 edition of the *West Plains Gazette*.

The obituary for James Jewell appeared in the March 28, 1935 issue of the *Quill* newspaper.

The obituary for Leonard Fite appeared in the October 27, 1938 issue of the *West Plains Journal*.

Initially, Joseph Wiser's grandchildren hesitated to talk to the author about their grandfather because they believed that lies had been told about him and his culpability in the explosion. Eventually, Barbara Morgan and Virginia Graham, children of Joseph and Clara Wiser's son Paul Fred, spoke at length on the telephone about their family. John Barton and Leona Jenkins were kind enough to share their memories of the Wiser family in telephone conversations in September 2007.

The story of Glen Moore and Helen McCallon was told to the author by their daughter Carol Moore McInnis, her brother Bob Moore and his wife Cindy. Details of the couple's elopement were drawn from their marriage announcement in the October 18, 1928 *Quill*.

The letter from Fern McBride appeared in volume 2 of the *Gazette* newspaper in the spring of 1979; quotations from it have been used with the permission of publisher Russ Cochran. On December 4, 2008, Steve McBride, grandson of Fern and Garrett McBride, contacted the author via e-mail. When his aunt reviewed papers left by the McBrides after their deaths in 1989, she discovered notes for the letter Fern had written to the *Gazette*. Mr. McBride shared with this author his memories of his grandparents.

On February 27, 2008, Jim McFarland shared family stories with the author and provided legal documents relating to the custody battle over his father and the obituary for Eugene Smith. Additional information was gleaned from Mary Jane McFarland's obituary in September 1993, Jack McFarland's obituary dated January 18, 2001, and a memorial written by Frank L. Martin III, editor of the *Quill*, on January 19, 2001.

Will H.D. Green's endorsement for reelection as prosecuting attorney of Howell County appeared in the May 31, 1928 *Quill*.

Frank "Daddy" Poole's obituary appeared in the November 7, 1935 *Gazette*.

The February 15, 1973 *Quill* obituary of C.R. "Babe" Lashley provided the information in the text.

Bront Luna's obituary appeared November 20, 1985. The obituary is included in the obituary books at the West Plains Public Library, but the source of the obituary is not noted.

The history of the Harlin family appeared in "The Harlin Brothers: The Story of an Ozark Dynasty" in the *Gazette*, no. 8, in the fall of 1980.

Carla Mullins Burns contacted the author via e-mail in September 2008 after seeing a posting about the book project on an online genealogy site. She generously shared information about her father for this book.

Charles Drago, current owner of the Robertson-Drago Funeral Home, spoke to the author on January 9, 2009.

Information about the West Main Street funeral home was culled from *Quill* issues dated May 10, 1928; July 5, 1928; November 1, 1928; November 8, 1928; and December 9, 1937. Information was also drawn from *Gazette* issues dated February 8, 1934; July 18, 1935; and January 4, 1939.

The stories of the music store owner who played "At Sundown" outside his store and the origin of "The West Plains Explosion" folk tune were told by Robert Neathery in his book *West Plains As I Knew It*, pages 191–98.

OLD GOSSIP AND
NEW THEORIES

In the days following the tragedy, a tide of supposition and rumor quickly filled the informational void created by the failure of the coroner's jury to deliver an explanation for the blast.

Joseph Wiser was quickly suspected as the perpetrator. Some believed that Wiser had bombed his garage to collect his business insurance because of his financial difficulties. Others believed that Wiser planned to collect the insurance money and run away with divorcée Ida Lee. A few suspected that desperation over his finances drove Wiser to suicide. Even his Pentecostal church's opposition to dancing was cited as reason for him to torch his garage in a fanatical attack on the dancers in Bond Hall.

Testimony from Wiser's friends and family about his sterling character, his religious moderation and his cheerful demeanor did not sway public attitudes. The testimony by Wiser's insurance agent and his banker regarding the minimal amount of insurance Wiser carried on his garage and his improving finances failed to stem the tide of animosity directed at the garage owner. Even today, most West Plains residents with any knowledge of the Bond Hall tragedy attribute the explosion to Joseph Wiser.

Another theory surfaced soon after the explosion. Three separate sources related this story to the author, but none wanted to be identified because of the sensitivity of the subject, even after more than eighty years. Most investigators believed that a fire inside Wiser's garage sparked the explosion, and one witness testified that he saw such a fire through a rear window of the Adams Building just prior to the explosion. Some theorists allege that the jilted lover of a woman who was attending the dance intentionally set the

blaze. A socially prominent and financially powerful businessman, the rejected suitor displayed courtly manners but possessed a vicious temper that he had failed to control on other occasions. Some years prior to the explosion, local newspapers reported an incident in which that businessman shot an unarmed man on a public street after a dispute. The wounded man brought charges against the shooter, but a Howell County judge dismissed the case. According to the rumor, when the man's paramour realized that he was not going to leave his wealthy wife to marry her, she broke off their relationship. On the evening of April 13, 1928, she and her new beau were together at the dance.

Some people believed that the philanderer, or people hired by him, set the fire in Wiser's garage. Whether he intended to just smoke the dancers out of the hall and embarrass the lady and her date or do bodily harm to the people assembled there is a subject of debate. Rumors name the jilted lover as one of several men observed leaving the scene of the explosion that night. However, none of the witnesses quoted in the coroner's jury report indicated recognition of this well-known individual, and the man's name was never mentioned in the accounts printed by local newspapers. Conspiracy theorists believe that officials intentionally covered up the man's complicity because of his powerful status.

A number of people reported seeing Wiser and two or three men in his garage that evening, and some believed that these men were responsible for the fire. Since witness after witness testified that Joseph Wiser was a man of character, it seems unlikely that he would have allowed a person, no matter how well connected, to set fire to his business. Drs. Toney and Thornburgh testified that Wiser suffered a blow to the head and an injury to his chin later characterized, perhaps erroneously, as a gunshot wound. Jurors considered the possibility of an attack on Wiser, but without verification, the tale remains an urban legend that speaks of resentment toward a powerful but disliked man in the community.

Robert Neathery, in his 2001 book *West Plains As I Knew It*, suggested another solution to the mystery. He questioned Wiser's mechanic, presumably Jim Jewell, about the explosion, and the mechanic admitted that a friend had asked to store a truckload of goods that included boxes of dynamite and blasting caps inside the garage that night. The mechanic agreed, presumably with Wiser's consent, so long as the trucker drove it away early the next morning. According to West Plains journalist Marideth Sisco, who assisted Neathery in writing his book, Neathery tracked down a Kansas freighter, who confirmed that his truck, packed with dynamite, had been stored in Wiser's garage.

Several witnesses to the coroner's jury testified to seeing Jim Jewell, Wiser's mechanic, driving an old truck just prior to closing time. Wayne Langston testified to the coroner's jury that Wiser told him that they would have to leave space in the garage for a Dodge truck that Jim Jewell was bringing in. Also, Dutch James described seeing Jewell driving "an old Dodge truck" at about 6:30 p.m.

Jim Jewell denied the story of a stored truck in his testimony before the coroner's jury. Perhaps the truck never existed, or perhaps Jewell believed that telling the coroner's jury about the truck might incriminate him or his friend. The jurors' intense questioning of Jewell, on two different occasions, seemed to indicate some doubts as to his veracity. If Jewell were protecting the freighter, his reluctant responses might have aroused the jurors' suspicions; perhaps the mechanic was nervous, intimidated by the prominent gentlemen, and taking care not to incriminate himself. He admitted that he had a key to the building, and he may have feared that he was under scrutiny as the perpetrator because he had access to the garage.

One juror specifically asked Jewell if he knew of any explosives (other than gasoline) stored on the premises. He answered that he did not. Jurors asked several questions about the Dodge truck, which might indicate that they had already heard rumors about its contents. Jewell testified that the truck was one of three vehicles transferred from Wiser's house that afternoon. He said that he drove the truck into the garage at about 5:30 p.m., not 6:30 p.m., as testified by Dutch James. When asked if any other vehicles had been stored in the garage that evening, Jewell answered, "Not while I was there."

Modern experts weighed in about the explosion and fire. A professional fire investigator, who requested anonymity, stated that the scenario presented too many variables for him to determine a cause of the explosion after eighty years. Those variables include the size, age, condition, type of construction and maintenance of the Ward Building. The mortar in old brick buildings, he said, becomes very weak and unstable with age, and even a relatively small explosion could cause such a structure to collapse.

Normally, fumes would rise within a building, but some type of barrier constructed between the first and second floors might have prevented fumes from rising into Bond Hall, and the vapors could have become concentrated to an explosive level within the garage without the dancers being aware of them. The fire investigator said that he had seen huge explosions from just twenty gallons of gasoline.

The modern expert confirmed the 1928 testimony of W.J. Orr who said that gasoline's explosive properties vary with interior and exterior temperatures and humidity. He said the "farm type" of tank that was present in Wiser's garage is no longer considered safe for indoor installation. In the past, people did not understand gasoline's explosive potential and often housed such tanks in barns and garages.

Relative to the theory of the truck stored overnight in Wiser's garage, the investigator opined that dynamite, properly packed for transport, would "most likely just burn." However, if a substantial amount of dynamite and fifty gallons of gasoline had exploded, the result would be "a hell of a hole in the ground."

The coroner's jury worried that Joseph Wiser's burns, less severe than the burns of other victims, were due to acid or some other chemical, but the arson investigator believed that the garage owner's burns, as described in the transcript of the coroner's jury, were consistent with Wiser being close to the initial flash of the blast.

Despite television shows starring forensic scientists who solve all unknowns, arson investigation is still an imperfect science, and some cold cases are just too cold.

"No matter how many schools I attend," the investigator said, "I see anomalies that surprise me."

Dr. Henry Macler, an anesthesiologist living in Felton, Pennsylvania, weighed in about Wiser's injuries. Dr. Macler has been called as an expert witness in a number of court cases, including the case of medical personnel accused of euthanizing terminally ill nursing home patients trapped by the floods of Hurricane Katrina. After reading the testimony of the undertaker who prepared Wiser's body for burial and the testimonies of the physicians who performed Wiser's autopsy, Dr. Macler concurred with the fire investigator's opinion that Wiser's proximity to the explosion would explain the pattern of burns.

Dr. Macler noted one peculiarity after reading the testimonies. Undertaker George Stapp testified that Wiser's skin was "fiery red in color," and Dr. Thornburgh described Wiser's face as "dark red" and "bright red." Stapp believed that the discoloration was due to acid burns, and the physician offered no explanation for the condition of Wiser's body.

Dr. Macler suggested that the red color might have resulted from exposure to carbon monoxide—a pink-cheeked, cherry red appearance is a classic symptom of carbon monoxide poisoning. Dr. Macler's evaluation would indicate that Wiser was alive long enough to breathe in toxic fumes from a fire.

The autopsy physicians believed that the burns on Wiser's hands indicated that he had been using gasoline at the time of the explosion. Mechanic Jim Jewell's testimony that Wiser had hoped to pay off his General Motors debt by returning parts for credit suggests a possible scenario: If the garage owner was cleaning auto parts with gasoline that evening, and he accidentally started the fire with a cigarette or from a spark struck by contact between metal parts, he might have breathed in toxic fumes as he tried to extinguish the blaze. Like the dancers on the floor above him, Wiser would have been blown upward by the blast, landing in the field behind the Ward Building.

To address another theory, Wiser could have been rendered unconscious by an attacker who set a fire to cover his crime or by the jilted lover intent on smoking his former girlfriend out of Bond Hall. Lying alive but insensible on the floor, Wiser could have breathed in the toxic fumes before his death in the explosion. Either of those scenarios would explain the fire seen by witnesses in Wiser's garage prior to the explosion and the final location of Wiser's body, but neither explains the enormity of the explosion.

Chief Tim Bean heads the contemporary West Plains Fire Department that employs twelve full-time employees and twenty-four volunteers. He knew of the 1928 explosion, but he had never explored the facts of the case. He concurred with the fire investigator's belief that dynamite and blasting caps, properly packed for shipping, should not have exploded. They would have simply burned away.

Chief Bean focused on the seemingly unusual pattern of the explosion that broke windows on the square and down Washington Avenue in a west and northwesterly direction from Bond Hall. The blast caused such extensive damage to the courthouse that it had to be demolished. However, the Ridgeway Dry Cleaners building, located directly behind the Adams Building, sustained only a blown-in door and broken windows. The twenty-seven-year-old Arcade Hotel, situated on Walnut Street, just southeast of the blast, survived the explosion after repairs and continued to lodge travelers for many years.

The concussion of an explosion follows certain rules of physics, according to Chief Bean. Without natural barriers such as mountains or man-made structures like high-rise buildings to direct the force of an explosion, the concussion spreads out in a circular pattern of destruction. For the explosion to have caused such extensive damage to the west and northwest of its detonation point and much less damage to the east and southeast seemed peculiar.

In 1928, B.N. Cade supplied a vivid observation of the explosion to local newspaper reporters: "In the center seemed to be a pale green circle

like a pinwheel in motion. At the edge, the green became a darker hue all surrounded by yellow flames."

Methane gas is one of the few substances that burn with a green flame, according to Chief Bean. He theorized the explosion might have resulted from methane gas leaking from a sewer, and the concussion of the blast could have followed the path of the city's sewer system back onto the square and down Washington Avenue. However, Terry Danahy, water and sewer superintendent for the City of West Plains, doubted that the sewer system directed the force of the explosion. Danahy said that in the late 1920s, the city's sewer system consisted of clay pipe vented only by the leakage from manholes located throughout the system. In a methane explosion, the concussion would blow upward through the manholes and/or follow the service lines into the buildings. If the force of the explosion had followed the sewer, damage would have been evident in the interior of buildings with secondary damage to the exteriors.

Although Danahy was not positive of the layout of the sewer system at the time of the Bond Hall explosion, he believed that the current system was constructed on the same pattern. A sewer line runs behind the Aid Hardware building east to Walnut Street. Feeder lines running in a north–south direction connect the buildings on East Main Street to that sewer line. The sewer line that services the courthouse enters the square from the north. No sewer lines run directly between the 100 Block of East Main Street and the square; therefore, the concussion of the explosion had no sewer route to follow between the Ward Building and the courthouse. Danahy commented that although he had never personally witnessed a methane explosion, he had seen training films in which small volumes of methane gas produced enormous explosions.

The rocky, porous karst geology of the Ozark region might provide another explanation of the force of the blast and the unusual pattern of damage. The first white settlers to West Plains settled around a spring located just east of where the Adams, Ward and Riley Buildings were built decades later. The author could locate no study of the geology specific to the area of the square, but if the spring flowed through an underground cavern that lay along an east–west directional from the spring under the Ward Building and west toward the square, the force of the blast might have followed its path.

Dr. James Miller taught geology at Missouri State University in Springfield for thirty-four years and is familiar with the old Howell spring. The existence of underground caves or caverns through which water flows is common throughout the Ozarks, he said, and the "spring under the location of

the explosion indicates some sort of underground cavity for water to flow through." If the concussion of the blast moved away from the Ward Building in a direction following the northwesterly course of an underground cavern or stream, the damage to the buildings to the west and north of Bond Hall might be explained.

Dr. Miller suggested another scenario to explain the volume of the explosion. Perhaps over many years, gasoline from the service stations that were clustered together in the vicinity of the square might have seeped through the porous karst crust into a cavity somewhere beneath East Main Street. An explosion or fire within Joseph Wiser's garage could have ignited the fumes accumulated beneath the surface, resulting in the massive explosion that destroyed so much of the city's downtown area.

"All sorts of strange stories abound in the Ozarks," Dr. Miller said. He recalled an incident recorded by Laura Ingalls Wilder—of *Little House on the Prairie* fame—who lived in Mansfield, Missouri, about sixty miles north of West Plains. She wrote about a man digging a well who was overcome by what she called "swamp gas," probably methane gas, according to Dr. Miller. In the story, Pa Ingalls heroically climbed down into the hole and brought the man to safety.

Ozark Underground Laboratory (OUL) in Protem, Missouri, is a private consulting and contract studies firm that provides groundwater tracing and various hydrogeological services throughout North America. Tom Aley is the principal hydrogeologist for OUL, and he has been studying the subterranean Ozarks for many years. He is an expert on the caves, caverns and sinkholes of the area.

Aley described the location of the Howell family spring as under the basement of the "old library building" in the 200 Block of East Main Street. To have a spring, according to Aley, "dissolved openings feeding the spring" must exist. These openings would be at a greater depth than sewer pipes in the area, and chemicals or gases that are flushed into the storm drains can seep into the deeper cavities.

Aley agreed with Chief Bean's suggestion about a possible connection between the explosion and the sewer system. Modern sewer systems are designed with pipes, conduits and vents to prevent a buildup of explosive gas, but old systems were not always so well constructed.

Regarding Dr. Miller's theory, records of blasts associated with leaks of explosive materials into caves are common, according to Aley. He recalled an incident in Georgia with multiple fatalities in which gasoline leaked from a service station into a cave, causing an underground explosion. Ignition

occurred when a group of Boy Scouts were exploring the cave with carbide lamps, and the flames from the lamps ignited the gasoline fumes. When rescuers tried to enter the cave to save the boys, they were overcome by carbon monoxide.

"When you have explosive gases in a sewer or cave, the explosion may extend along that conduit for an appreciable distance," said Aley. "In such a case, the severity of the explosion may vary along the conduit depending upon the volume of explosive material that is ignited in particular areas. This could account for the observations that the severity of the damage did not decrease radially outward from the presumed point of the explosion."

Aley reinforced the eighty-year-old testimony of W.J. Orr, the modern assertions of Fire Chief Tim Bean and the fire investigator that a small amount of gasoline can produce very large explosions. Generally, gasoline and air do not mix in the proper proportions to cause an explosion, but when the mixture is right, massive detonations can result. Aley said that he once investigated a school explosion in Marshfield, Missouri, in the 1990s. When a student flipped on the light switch in a storage closet at the school, propane gas from a leaky propane line exploded. Rain had flushed the propane into the basement of the school, and the gas exploded with the spark of the light switch.

At the time of the Bond Hall explosion, individuals reported hearing the blast twenty-eight miles away. Aley recalled that the 1970 explosion of a truck hauling explosives on Interstate Highway 44 west of Springfield was heard twenty miles away.

Concurring with the fire investigator, Tom Aley stated that a forensic investigation of the Bond Hall explosion is eighty years too late. A conclusive cause of the death and destruction that occurred on that rainy night of April 13, 1928, is lost to the ages.

Sources

Robert Neathery's *West Plains As I Knew It*, pages 191–98. Marideth Sisco met with the author on February 5, 2009, to discuss Robert Neathery's theory about the explosion.

The story of the jilted lover's alleged involvement in the explosion was confirmed to the author by multiple sources. However, due to the sensitivity of the issue—even after eighty years—all of these individuals asked to remain anonymous.

The professional fire investigator spoke to the author on February 18, 2008, on the condition of anonymity.

B.N. Cade's account of the explosion was reported in the April 19, 1928 *West Plains Gazette*.

Dr. James Miller, Chief Tim Bean, Dr. Henry Macler and Dr. Tom Aley spoke with this author in August 2008. Dr. Aley kindly followed up with a letter in October 2008 confirming this author's interpretation of his comments and expanding on his earlier statements.

EPILOGUE

A stroll around today's West Plains courthouse square evokes a sense of time misplaced. Local publisher and preservationist Russ Cochran estimates that 75 percent of the buildings in the downtown business district appear the way they did in the 1920s.

Most of the historic buildings that encircle the Howell County Courthouse and radiate outward along the four streets anchored by the square have been restored through the efforts of Cochran and Toney Aid, grandson of West Plains pioneer C.T. Aid; other structures on the square and along Washington Avenue are currently under renovation. Many of the buildings, including the exquisitely restored Catron Opera House, are protected by the National Register of Historic Places.

In the 1970s and 1980s, the West Plains downtown business district fell into disrepair. Much of the credit for the renovation of the square goes to Cochran and Aid, two hometown boys who collaborated to breathe renewed life into the city's core.

"Being a preservationist means wanting things to stay the same," said Cochran. "All of us are resistant to change. I realized what a vital place the square was as a little boy, [and] I'm happy to see part of that coming back."

Toney Aid is the son of Reba and Joe Aid Jr., who as a teenager snapped the photos of the smoking ruins of the Ward, Riley and Adams Buildings that were seen around the world. Toney's grandfather, C.T. Aid, was one of the earliest pioneers in the business life of West Plains, and the building that housed the venerable Aid Hardware store still anchors the south side of the square at the intersection of Aid Avenue, just as it has since the town's earliest days.

The 100 Block of East Main Street in West Plains in 2010. *Photo by Lin Waterhouse.*

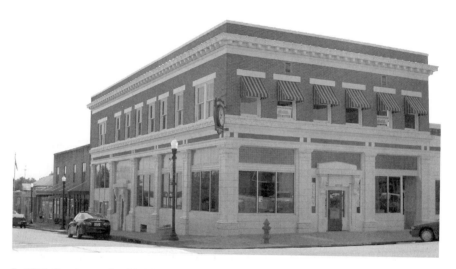

In 2010, flooring on the third floor of the newly renovated bank building still bears scorch marks from the explosion and fire. *Photo by Lin Waterhouse.*

Aid no longer operates a hardware store in his grandpa's old building. He gave up the business when Walmart began selling hammers cheaper than he could order them from his wholesaler. He and his wife, Kathleen, live on the third floor of the renovated building that was constructed by C.T. Aid back in 1920. The second floor contains apartments and offices, and the mezzanine houses a bookstore stocked with volumes about the Ozarks and by Ozark authors. The Aids oversee an antique mall on the ground floor of the building. Just inside the old display windows that overlook the

square, folks gather in a tiny café to sip lattes and cappuccinos, to chat and to read the *West Plains Daily Quill*, still in publication after more than one hundred years.

Despite its historical appearance, modern capitalism blooms in the renovated buildings that shelter a card shop, a fine dining restaurant, a bank, an art gallery and frame shop and a number of specialty shops and offices. Russ Cochran's son, Jack, operates the Red Apple Grill, a 1950s-style hamburger joint where his father and other musicians gather to jam on Saturday nights.

The population of West Plains hovers at about eleven thousand, merely thrice what it was in 1928, and most folks who live in the town like it that way. Community leaders work to keep the city small, friendly and safe.

A conservative attitude is fostered by the large presence of religion in the town that nests happily within America's Bible Belt. The business pages of the 2010 CenturyLink telephone directory lists thirty-six churches with West Plains addresses. Traditional mainline churches such as the Methodist, Presbyterian, Episcopal, Catholic, Lutheran and Baptist denominations are

People still leave flowers at the memorial to the unidentified dead. *Photo by Lin Waterhouse.*

represented, but the influence of fundamentalist and Pentecostal faiths is reflected in multiple numbers of Churches of Christ, Assemblies of God, Churches of God and other Bible-based congregations.

Joe Paul Evans, the current mayor of West Plains, has a direct connection to the Bond Hall disaster. His uncle Paul Evans attended a movie on the evening of April 13, 1928, and decided to stop by the dance before heading home. He arrived in time to die in the street in front of the Ward Building. The young man's parents, Dr. and Mrs. Paul Evans Sr., were in their home on Grace Avenue when they heard the explosion.

"Paul just died," Mrs. Evans said to her husband.

"I know," said Dr. Evans. "I'll go get him."

Kitty McFarland's dream of turning the brick residence on West Main Street into a lovely mortuary was fulfilled, and today Charles Drago, whose aunts Billy and Susan died that night, operates the Robertson-Drago Funeral Home at that location.

Although time has erased memories of the dead in the West Plains community and the Bond Hall explosion is more myth than fact, people still place flowers at the granite monument that marks the graves of the unidentified victims at Oak Lawn Cemetery. Although the author offers no clear cause or culpability for the explosion, perhaps this retelling will allow the ghosts of the past to rest in peace.

SOURCES

Russ Cochran spoke to this author in 2004 and 2006 for articles in the *Ozark County Times* newspaper and *Ozark Magazine*, respectively.

Toney Aid's decision to close the hardware store when Walmart began selling hammers at too low a price was told to the author by Russ Cochran in a 2004 interview.

The story of Paul Evans's late arrival at the dance was told in newspaper accounts of the time and in the testimony of his friend, Ray Daughtery, before the coroner's jury. Journalist Marideth Sisco related to this author the story of Evans's parents' startling realization of their son's death as told to her by West Plains mayor Joe Paul Evans.

VICTIMS OF THE
BOND HALL EXPLOSION

West Plains, Missouri
April 13, 1928

IDENTIFIED DEAD

John Bates, twenty, single, studied civil engineering at the University of Arkansas in Fayetteville, son of the Reverend J.F.E. Bates, Methodist minister, West Plains.

Clinton Clemmons, twenty-three, single, worked at Davis Grocery, son of Mr. and Mrs. T.D. Clemmons, secondhand dealers, West Plains.

Paul Evans Jr., twenty-three, single, University of Missouri graduate, dairy farmer, son of Dr. Paul Evans (state horticulturist), West Plains.

Charles Fisher, twenty, single, student at Kirksville Teachers College, only son of Mr. and Mrs. A.P. Fisher of Ava, Missouri.

Carl Jackson, nineteen, single, high school senior, Mountain Grove, artistically gifted, buried in double funeral with friend Charles Fisher.

Jullius C. Jeffrey (shown in one obituary as "Jeffers"), single, Mammoth Spring, Arkansas.

Ben Jolly, sixty-eight, painter and employee of McFarland Undertaking Company.

Robert G. Martin, fifty-four, Ford dealer, Masonic leader, West Plains, husband of Soula Maxey Martin and father of Soula Gaines Martin, cosponsor of the dance.

Soula Gaines "Dimple" Martin, twenty-one, daughter of Mrs. and Mrs. R.G. Martin, crushed by the piano she had been playing.

Soula Maxey Martin, wife of Robert Martin and mother of Soula Gaines Martin, prominent businesswoman and socialite in West Plains, cosponsor of the dance.

Mary Katherine "Kitty" McFarland, thirty-one, proprietor of McFarland Undertaking Company, widow of Ray McFarland, mother of twelve-year-old Jack, rumored to be engaged to Major Robert Mullins.

Charles Merk, seventeen, high school student, son of Arnold Merk, contractor, West Plains.

Naomi Reeves Mullins, nineteen, pregnant wife of Carl Mullins

Major Robert (Bob) Mullins, thirty-four, overseas veteran of World War I, officer in 140th NGM, commission and storage man, rumored to be engaged to Kitty McFarland.

Lev Reed, twenty-six, head of legal department of Reed-Harlin Grocer Company, owned by his father, John R. Reed.

Mabel Daum Riley, twenty-five, wife of Esco Riley, Blythesville, Arkansas.

Hazel Slusser, twenty-three, single, schoolteacher from Willow Springs, daughter of H.T. Slusser, retired newspaper editor.

Elbert White, nineteen, a singer at the Presbyterian church in Doniphan, member of National Guard, died one week after explosion, son of Mrs. E.N. White of Doniphan. Elbert and his brother David operated the West Plains–Poplar Bluff bus service.

Joseph M. "Babe" Wiser, forty-six, West Plains, owner of Wiser Motor Company, husband of Clara.

MISSING AND PRESUMED DEAD

Mary Violet Adair, seventeen, single, daughter of Mr. and Mrs. Charles H. Adair, West Plains.

Beatrice Barker, seventeen, single, daughter of Mr. and Mrs. I.B. Barker of Mountain Grove. Her dentist unsuccessfully attempted to identify her body through dental records.

Evelyn Flo Conkin, twenty, single, daughter of Mrs. and Mrs. Houston Conkin of Kansas City, sweetheart of Mo Ashley, cousin of Lev Reed, niece of Mayor Jim Harlin.

Frances Wilhelmina (Billy) Drago, twenty-two, single, manager of Western Union, daughter of Mrs. and Mrs. Charles Drago.

Ruth Fisher, eighteen, single, daughter of Mrs. and Mrs. Fred E. Fisher, West Plains. Ruth was attending her first public dance.

Boyd Garner (also shown as Alvin Garner), twenty-one, Mammoth Spring, Arkansas.

Marvin Hill, nineteen, member of National Guard, son of Mr. and Mrs. Ed Hill, West Plains.

Ruby Hodkinson, twenty-two, Kansas City, married to Clifford Hodkinson, mother of a three-year-old son, visiting her cousin in Cabool, Missouri.

Olis "Chester" Holestine, twenty-two, son of J.F. Holestine, Ava, Missouri. Olis was playing the saxophone at time of explosion.

Juanita Marie Laws, twenty-seven, single, Kansas City, visiting her parents in Cabool.

James Loven, twenty-two, single, Mammoth Springs, Arkansas.

Carson McLelland, twenty-five, single, state highway department employee, son of Mr. and Mrs. Wellington McLelland, Chapin, Missouri.

Nellie James Murphy, twenty-four, wife of Robert Murphy of Springfield, daughter of Mr. and Mrs. Pleas "Dutch" James, West Plains.

Robert Sholten Murphy, thirty, Springfield, owner of Murphy Tire Company, Springfield, son of Mr. and Mrs. Steve Murphy, husband of Nellie Murphy.

Esco Riley, twenty-seven, head of sales at Allen Grocery, son of Mr. and Mrs. E.L. Riley of West Plains, husband of Mabel Daum Riley.

H.K. Newton Riley, twenty, single, member of National Guard, worked at Allen Grocery, son of Mr. and Mrs. E.L. Riley, West Plains.

Icie (Icy) Risner (sometimes spelled Risener), twenty-three, single, elementary school teacher in Thayer, daughter of J. Willard Risner (livestock dealer), Thayer.

Susan Virginia Drago Rogers, nineteen, wife of Wallace Rogers, Emporia, Kansas, mother of one-year-old daughter Patricia, daughter of Mr. and Mrs. C.H. Drago, West Plains.

Hugh Sams, nineteen, single, member of National Guard, son of Mr. and Mrs. Sid J. Sams, West Plains.

INJURED

Lewis Acuff, employee of Hull grocery; severe burns on face, hands and arm; left ankle broken and dislocated.

Dail Allen, son of H.C. Allen, musician; internal injuries; broken collarbone; severe cuts and bruises on back.

H.C. "Lum" Allen, grocery merchant; severe burns on face, hands, back; leg crushed from ankle to knee.

Fred Archer, Mountain Grove; burns on right hand, arm and foot; crushed ankle.

Mo Ashley, son of J.D. Ashley, wholesale grocery dealer, West Plains; burns, cuts and bruises.

Roy Crain, clerk at Bohrer's Drug Store; bruises on face, hands and legs; severe cuts over entire body.

Ernestine Cunningham, Willow Springs; severe burns; rescued from fire by Glen Moore.

William Fitchett, West Plains Glass Company; severe hip injury.

Mrs. William Fitchett; hip, knee and ankle injuries; head wound; no burns.

Boyd Gray, Moody, Missouri, brother of Mrs. Fitchett; sprained ankle; burns on face and hands.

Ralph Langston Jr., local high school athlete and grandson of T.J. Langston of Langston-Pease Mercantile Company; severe burns on hands and face; only victim treated at Cottage Hospital.

Fern Pumphrey McBride, wife of Garrett; three fractured vertebra; ankle fracture.

Garrett McBride, druggist, McBride Drug Company in West Plains.

Glen Moore, employee of Reed-Harlin mercantile, local baseball player; crushed left arm; burns on hands and face.

Carl Mullins, musician, son of H.R. Mullins (local wholesale grocery dealer); eye and hip injury; fractured ribs.

John Riley, son of Con Riley, West Plains; burns on face and hands.

Charles Stockdall, high school senior, Mountain Grove; burns on hands, face and feet; both ankles sprained.

Clias Unger, Cabool; crushed left leg; burns on right foot, hands and face.

David S. White, operated a bus line between West Plains and Poplar Bluff with his brother, Elbert, who died following fire, was dancing with Billy Drago when explosion occurred; suffered burns and cuts when blown from building.

Elton White, seventeen, employee of Laird Plumbing Company; burns on hands and face.

Guy Wilson, high school athlete, son of John Wilson, West Plains; suffered cuts, bruises and burns.

ABOUT THE AUTHOR

Lin Waterhouse is a freelance writer who focuses on the historical curiosities of the Ozarks region. Her work has been published in the *Ozarks Mountaineer*, *Ozarks Magazine*, the *Ozark County Times* and the *St. Louis Post-Dispatch*. After writing an anniversary piece about the mysterious 1928 dance hall explosion in West Plains, she continued researching the story that piqued her curiosity and offended her sense of historical justice. This book is the result.

Photo by Kelli Albin.

Visit us at
www.historypress.net